PEABODY
MUSEUM
COLLECTIONS
SERIES

Collecting the Weaver's Art

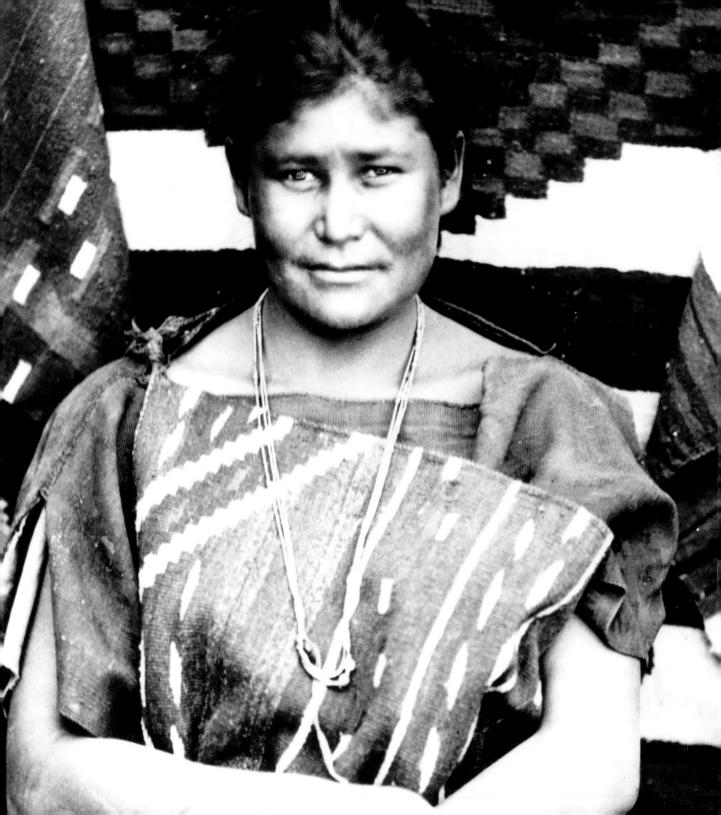

COLLECTING THE WEAVER'S ART

The William Claflin Collection of Southwestern Textiles

Laurie D. Webster

Foreword and commentary by Tony Berlant

Photographs by Hillel S. Burger

Rubie Watson, Series Editor

Peabody Museum Press, Harvard University

Editorial direction by Joan K. O'Donnell

Copy editing by Jane Kepp

Cover and text design by Kristina Kachele

Composition by Kristina Kachele in FF Atma Serif Book and Gill Sans with Serlio and Gill Sans Light display

Color separations by iocolor, Seattle

Printed and bound in China by C&C Offset Printing Co., Ltd

ISBN 0-87365-400-5

Library of Congress Cataloging-in-Publication Data:

Webster, Laurie D., 1952–
Collecting the weaver's art : the William Claflin collection of southwestern
textiles / Laurie D. Webster ; foreword and commentary by Tony Berlant;
photographs by Hillel S. Burger.
p. cm. — (Peabody Museum collections series)
Includes bibliographical references.
ISBN 0-87365-400-5 (pbk. : alk. paper)
1. Navajo textile fabrics—Themes, motives—Catalogs. 2. Pueblo
textile fabrics—Themes, motives—Catalogs. 3. Indian textile
fabrics—Collectors and collecting—Southwest, New—History—Catalogs.
4. Claflin, William H. (William Henry), b. 1893—Ethnological
collections—Catalogs. 5. Peabody Museum of Archaeology and
Ethnology—Catalogs. I. Berlant, Anthony. II. Burger, Hillel. III.
Peabody Museum of Archaeology and Ethnology. IV. Title. V. Series.
E99.N3.W43 2003
746.1'4'089972—dc22

2003020948

∞ The paper used in this publication meets the minimum requirements of the American National Standard for Information Sciences—Permanence of Paper for Printed Library Materials, ANSI Z39.48-1984.

FRONTISPIECE: Hadika, a Navajo woman, against a backdrop of Late Classic–period serapes, 1879. Photograph probably taken at the First Mesa Hopi village of Walpi, where John Hillers made several portraits of Navajo individuals. Peabody Museum, Harvard University, photo N35487. John K. Hillers, photographer.

Contents

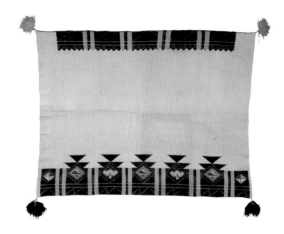

Illustrations

PLATES

AN ARTIST'S PERSPECTIVE

Tony Berlant

AS A VISUAL ARTIST, I have long been enthralled by the transcendent beauty of Southwestern textiles, especially Navajo blankets. This indigenous tradition has a strangely congruent relationship with abstract contemporary painting. The imagery in Navajo blankets emphasizes a nonphysical view of the world, an unseen order of the universe that is expressed through abstract metaphor rather than naturalistic depiction. Many contemporary painters have recognized kindred spirits in these blankets' makers, previously unknown ancestors whose sense of color, scale, and form was similar to their own. Other artists have simply appreciated the blankets as great works of art.

Shortly after the turn of the twentieth century, painters such as John Sloan, Marsden Hartley, and Georgia O'Keeffe embraced the Southwest. They found the art, the landscape, and the Natives' still-living ceremonial traditions vibrant and inspiring, with a link to modernist values. That Navajo blankets were woven rather than painted did not blind them to their importance. During the abstract expressionist

years of the 1940s and 1950s, another generation of artists—among them Jackson Pollock, Barnett Newman, and Adolph Gottlieb—was profoundly affected by the Native art of the Southwest.

In 1969, I was teaching in the art department of the University of California at Los Angeles when I found a Navajo blanket in the back room of a Persian rug dealer. My immediate reaction was to think that here was a work that might have been woven by Mondrian in a previous life.

I bought what turned out to be a second-phase chief blanket and hung it on a wall in my living room, studying it for several hours each day. Gradually I found myself absorbed in a world that was somehow paradoxically familiar and yet clearly outside my personal experience. As a child, I had traveled several times to the Southwest with my parents, who were enchanted by the mystique and aesthetic of the area and collected contemporary Indian art, but I could find no one who knew much about these blankets. I was gratified finally to discover the book *Navaho Weaving: Its Technic and History* (1934), by Harvard graduate Charles Avery Amsden, a long-time curator of the Southwest Museum in Los Angeles. Although the book allowed me to categorize blankets as, say, second-phase chief style or serape or Germantown and to date them approximately, my focus was more subjective: I wanted to experience the space and energy—indeed, the very presence—of the Navajo weaver and her world across time and space.

Shortly after this, New York sculptor Donald Judd visited me in Los Angeles. Judd was already familiar with Navajo blankets—the first person I had found who knew something about them. I had begun to collect blankets seriously, and I showed him my collection of perhaps seventy-five in all. Judd came back with painter Frank Stella, and I traded each of them a blanket for a work of theirs. Over lunch, partially in response to my complaints about teaching for a living, they convinced me to give up my UCLA job and concentrate on helping artists build blanket collections. I was easily convinced. All I had to do was show the blankets. Regardless of their own personal approaches, artists immediately shared my intense visceral reaction to these weavings and the powerful abstract vision they conveyed. The artists whom I helped collect blankets at this time included Andy Warhol, Jasper Johns, Robert Rauschenberg,

Jules Olitski, Larry Pons, Sam Francis, Ed Moses, Ken Nolan, Brice Marden, David Novros, Tony Caro, Allen Jones, Tony Smith, Arman, Richard Diebenkorn, Jim Dine, Michael Heizer, and Roy Lichtenstein.

That artists were profoundly attracted to Navajo blankets was logical. With their abstract imagery, powerfully conveyed energy, and bold scale, the blankets clearly related to what many of these artists, especially the abstract painters, were expressing in their work. Yet there was a fundamental difference between the two cultures in the way abstract imagery was received. Although the concept of abstract art is no longer controversial in our society, neither is it widely understood. In the more integral Navajo culture, all members of the tribe shared an appreciation for the abstract imagery of these blankets. Rather than evolving as an art form accompanied by a heavily intellectualized construct, Navajo blankets, observed painter Kenneth Nolan, "grew out of the air and earth of America, something that could only have happened here."

In fact, Navajos wove their blankets on looms built from tree trunks set in place with rocks. Wool came from sheep raised by the weaver, and yarn was carded, spun, and dyed with the weaver's own hands. The blankets were woven vertically from bottom to top and so seemed to have taken shape and grown directly out of the earth. Unseen forces influenced the blankets as well. The deity known as Spider Woman taught the Navajos how to weave and guided the weaver's hands. Her divinely inspired designs were abstract representations of the Navajo country landscape, with its vast horizon and enormous sky. In their striped blankets, Navajos seemed to merge with the striated rock formations found throughout their territory. At other times, the patterning of the blankets appeared to make them shimmer, an effect not unlike that of light and atmosphere in the heat of the desert.

A Navajo blanket, in its proportion and the placement of its design elements, bestowed a vital energy upon the wearer, much the way a sandpainting functions in Navajo spiritual beliefs. When an individual sat in the middle of a sandpainting during a sacred ritual, he or she achieved balance and protection. It seems that in a similar fashion, a Navajo blanket wrapped around the wearer placed the individual within a protective mandala. Each blanket was individual in design and represented the woman who wove it. Wearing a Navajo blanket is the key to understanding its pattern

and imagery. When it is draped like a cape around the body, the ends are brought forward and pulled together across the arms. This reveals the essential design concept: for example, in a third-phase chief blanket, two half-diamonds at either end are brought together, forming a whole diamond across the front of the body, a repeat of the diamond pattern in the back. Design elements break at just the right places, often following the lines of the arms. Strong vertical lines, carefully placed, reinforce the line of the spinal column.

Blankets were also multifunctional in Navajo culture. They were placed on the ground to sit on (but were never used as rugs). At night, blankets and sheepskins formed the Navajos' beds, and doors to their dwellings were often shielded with a hanging blanket as well. Viewed in this last way, a blanket was experienced much like a painting.

Most blankets were simple striped pieces, but blankets like those William Claflin focused on collecting—which are well represented in the present volume—served as symbols of status and power, traded to other tribes and cultures. In this sense, their function was similar to one of the functions of art in our own culture. These blankets were valued both as aesthetic objects and for their qualities as finely woven, warm, and even water-resistant garments.

I had the privilege of meeting William H. Claflin Jr. at his Boston home in 1971 with Mary Hunt Kahlenberg, then the curator of textiles and costumes at the Los Angeles County Museum of Art. We were assembling an exhibition for the museum that would travel internationally, the first show dedicated exclusively to Navajo weaving as art. Claflin was excited to find that, after a long hiatus, people were appreciative of the blankets, and I was struck by his dedication and passion in building a great collection. Claflin focused primarily on blankets woven before textiles became essentially controlled by trading posts and machine-made blankets replaced handwoven ones for Native use. Claflin's enthusiasm for his blankets made it clear that he thought of these works not as personal possessions but rather as an opportunity to assemble a gift for Harvard's Peabody Museum and the world beyond. Laurie Webster has acted out of the same enthusiasm in bringing Claflin's collection to a broader audience in this engaging book.

ACKNOWLEDGMENTS

MANY PEOPLE CONTRIBUTED to the writing of this catalogue. I especially wish to
acknowledge the assistance of two of them. Susan Haskell, collections associate at the
Peabody Museum, helped me with this project every step of the way, beginning with
my evaluation of the Southwestern textile collection in the fall of 2000 and continuing
through the writing of this catalogue. I am grateful for all her help and advice and for
her tireless research on Eliza Hosmer. I could not have conducted the project without
her. I also wish to thank Joan O'Donnell, editorial consultant to the Peabody Museum
Press, for her patient guidance and support and her upbeat attitude. Every author
should be fortunate enough to work with an editor like Joan.

Other people at the Peabody Museum who deserve my appreciation are Rubie
Watson, director of the museum and series editor, for her enthusiastic support of
the project; Steven LeBlanc, for facilitating access to the collections; Viva Fisher, for
assisting me with the history of the William Claflin accession and putting me in touch
with the Claflin family; Castle McLaughlin, for sharing her research about William

Morris; T. Rose Holdcraft, for sharing information about textiles on exhibit; India Spartz, for assistance with the photo archives; and Donna Dickerson, of the Peabody Museum Press, for attending to my many questions about the publication process. I would also like to thank former Peabody Museum staff members Susan Bruce and Penelope Drooker for their part in bringing me to the museum to assess the Southwestern textile collection in 2000. Finally, I wish to acknowledge a former Peabody Museum volunteer whom I never had the pleasure to meet. Barbara McCue held a deep appreciation for the Peabody Museum's Southwestern textiles. The research fund established in her memory funded my initial assessment of the collection and contributed to the publication of this book. I wish she were here to see the results of her generosity.

Several of William H. Claflin Jr.'s descendants shared biographical details of his life and helped me develop a better understanding of Mr. Claflin as a father, a businessman, a collector, and an archaeology enthusiast. Anne Claflin Allen, Bill's youngest daughter, gave freely of her time and helped me get the details straight. She and four other family members—Bill's daughters Helen Spring and Katherine Weeks and sons-in-law John Spring and John Weeks—took the time to read and comment on an early draft of the biographical chapter on Bill Claflin, and their comments were very helpful. I am extremely grateful for their input.

Textile scholars Marian Rodee and Kathleen Whitaker reviewed the manuscript and offered a wealth of valuable suggestions, observations, and insights. This book a far better product as a result of their feedback. Jane Kepp copy-edited the manuscript and pared down my prose. My thanks also go to Sarah Peabody Turnbaugh, curator of the Museum of Primitive Art and Culture, for sharing information about Rowland Gibson Hazard II, and to Judith Parker, for granting me permission to use her photograph of William Claflin. Finally, I wish to acknowledge the support of my family, colleagues, and friends, especially Jim Davis, who kept me well fed and content throughout this entire process. I dedicate this book to the memory of my mentor, Kate Peck Kent.

Collecting the Weaver's Art

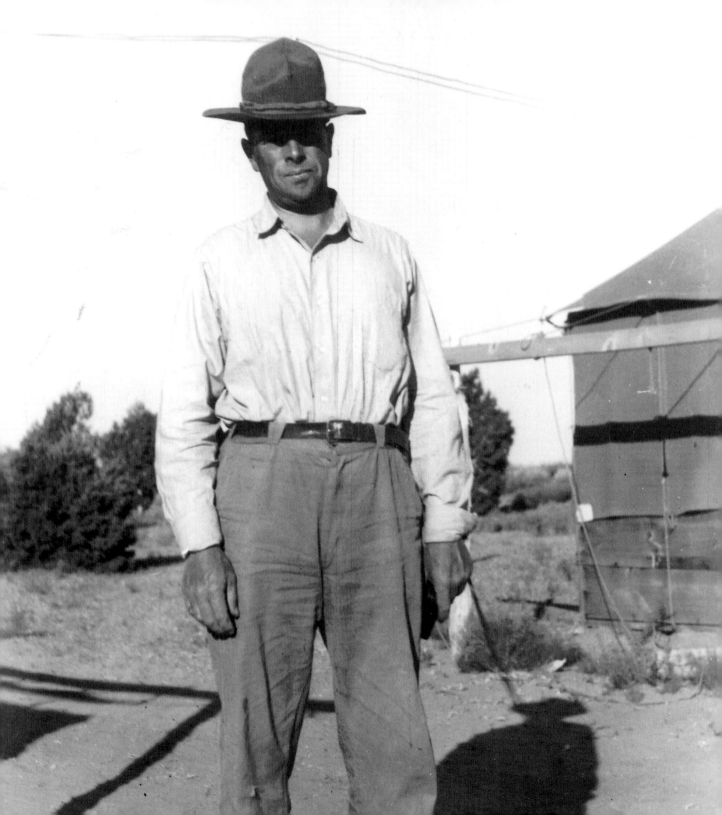

William H. Claflin Jr. and the Making of a Collection

THE TEXTILE COLLECTION assembled between 1910 and 1940 by prominent Bostonian businessman and museum philanthropist William H. Claflin Jr. constitutes the most important group of Southwestern weavings compiled by a single donor at Harvard University's Peabody Museum of Archaeology and Ethnology. Through Mr. Claflin's bequest, the Peabody Museum acquired sixty-six Native American weavings from his private textile collection: fifty-four Navajo textiles, eight Pueblo textiles, and four serapes of either Navajo or Pueblo manufacture. The collection includes outstanding examples of Navajo serapes, chief blankets, and women's two-piece dresses, as well as Pueblo serapes, kilts, and mantas. Bill Claflin collected some of these weavings himself during his trips west, but the pieces of greatest historical significance were collected by others—military personnel, Indian agents, early travelers, and the like—who visited the American West and Southwest during the mid- to late nineteenth century, sometimes obtaining their weavings directly from Native people. As Bill Claflin acquired each new piece, he painstakingly recorded information about

William H. Claflin Jr. at the Peabody Museum's Awatovi field camp in the late 1930s.
Peabody Museum, Harvard University, photo N35488.

its construction techniques, raw materials, and collection history. Thanks to his care and diligence, the Claflin collection is more than just an exquisite assemblage of Southwestern weavings. It is also a collection of unique historical lore, one with many stories to tell.

William Henry Claflin Jr. (1893–1982) was born in Swampscott, Massachusetts, the second son of Carrie Stetson Avery and William Henry Claflin.[1] He was educated at Noble and Greenough School in Boston and at Harvard University, where he graduated with a degree in liberal arts in 1915. Immediately after college, Bill, as he was known, took a job in the banking business, but he soon realized that he was not quite ready to settle down. Enlisting in the National Guard, he spent most of 1916 in El Paso, Texas, preparing for possible fighting with Mexico during the Mexican Revolution, though he never engaged in battle. In 1917 he married Helen Atkins; the couple would eventually have a son and three daughters. Soon after completing officers' training camp in Plattsburgh, New York, Bill was shipped out to Europe as a captain with the 302d Field Artillery. In 1919 he returned from service in the First World War.

Early in his career, Bill Claflin worked as a buyer for the Lampson and Hubbard Corporation, a hat manufacturing firm. His job took him on a number of fur-buying trips to Hudson Bay, and these experiences contributed to his growing interest in Native American lifeways, clothing, and textiles. In 1923 he became involved in his wife's family's sugar business and began spending winters in Cuba. He held a number of prestigious positions during his business career, including president and director of the Soledad Sugar Company, president of the Boston Stock Exchange, director of the Second National Bank of Boston, and director of the United Fruit Company. He also worked for the Rockefeller Foundation, served as treasurer of the Boston Museum of Fine Arts, and from 1938 to 1948 was treasurer of Harvard University, which bestowed on him the honorary degree of LL.D. in 1949. Throughout all this, he still found time to raise a family, serve as head coach of the Harvard hockey team, and nurture his strong interests in fine art, the outdoors, and anthropology.

The young Bill Claflin had a keen interest in archaeology and ethnology. At the age of seven he discovered his first arrowhead, which launched a lifelong passion for collecting and curating archaeological and ethnographic objects. Because of Bill's child-

hood health problems, he and his family spent winters in Augusta, Georgia, and it was there, at nearby Stallings Island, that Bill began his career as an avocational archaeologist. He undertook his first excavations on Stallings Island at the age of fifteen, working on his own with the help of a few laborers, and returned to conduct additional excavation work in 1921 and 1925. Several years later, in December 1928, he returned once again to Stallings Island, this time in the company of Peabody Museum archaeologists Cornelius B. (Burt) and Harriet (Hattie) Cosgrove. The team spent the next two months at the site. In 1931 Claflin produced a monograph on the excavations in the Peabody Museum Papers series: *The Stallings Island Mound, Columbia County, Georgia.*

Bill Claflin's first area of anthropological interest was the southeastern United States, but his attention soon spread to the American Southwest and other parts of the world. In August 1912 he made his first visit to the Hopi Mesas, where he collected several Hopi textiles that are believed to be the earliest acquisitions in his textile collection. That visit to the Hopi country instilled a lifelong interest in Hopi culture, culminating in Claflin's involvement with the Peabody Museum's Awatovi Expedition in the 1930s.

Bill Claflin and his wife, Helen, were early financial contributors to the Peabody Museum, and they also participated in some of the museum's early archaeological fieldwork in the Southwest. They helped support Samuel Guernsey's work in northeastern Arizona (1920–1923) and spent two weeks on the project in 1923, excavating Basketmaker and ancestral Pueblo sites alongside noted archaeologist Alfred Vincent (A. V.) Kidder. The Claflins also contributed to Burt and Hattie Cosgrove's Mimbres research in southwestern New Mexico (1924–1927). This support led to the publication of two additional volumes of the Peabody Museum Papers: Guernsey's 1931 volume, *Explorations in Northeastern Arizona,* and the Cosgroves' 1932 publication, *The Swarts Ruin: A Typical Mimbres Site in Southwestern New Mexico.*

Prompted by a suggestion from Kidder, Bill Claflin and his friend Raymond Emerson took a pack trip to a remote part of southern Utah in the fall of 1927 to evaluate the area's potential for further archaeological exploration. That trip laid the groundwork for the Claflin–Emerson Expedition (1928–1931), four years of archaeological research by the Peabody Museum in southeastern Utah sponsored by the

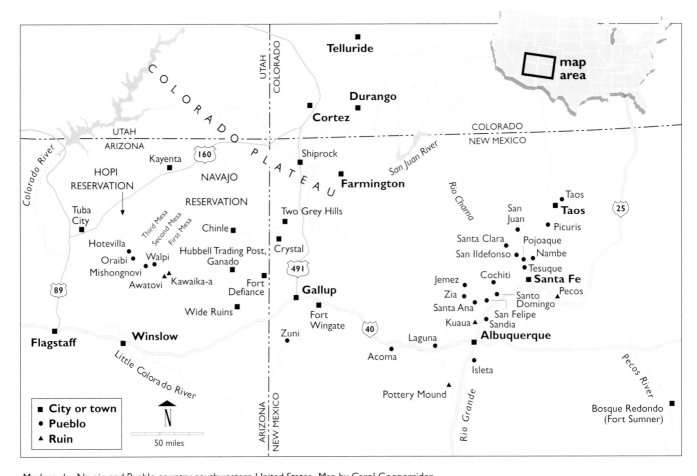

Modern-day Navajo and Pueblo country, southwestern United States. Map by Carol Cooperrider.

Claflin and Emerson families. One recipient of this funding was Noel Morss, whose fieldwork west of the Colorado River led to his identification of the Fremont culture and his 1931 publication, *The Ancient Culture of the Fremont River in Utah: Report on the Explorations under the Claflin–Emerson Fund, 1928–29*. Another beneficiary was John Otis (Jo) Brew, with whom the Claflins were to form a close personal relationship. Although the Claflins and Emersons did not participate in the expedition fieldwork to any great degree, Bill did engage in some archaeological work at Pecos Pueblo, New Mexico, in 1929, while visiting Kidder and his crew from the Phillips Academy of Andover, Massachusetts.

Without question, the Claflins' most important contribution to Southwestern archaeology was their support of the Awatovi Expedition. Between 1935 and 1939, under the direction of Jo Brew, the Peabody Museum conducted excavations at the ancestral Hopi site of Awatovi and its associated seventeenth-century Franciscan mission, as well as other sites in the region. In his introduction to the Franciscan Awatovi report, Brew identified William Claflin not just as a major financial contributor to the Awatovi Expedition but as the originator of the project itself:

> The Awatovi Expedition grew out of Mr. Claflin's interest in the prehistory of the Hopi country. During various trips to northern Arizona he had acquired a thorough knowledge of the Reservation which has been of inestimable value to the Expedition. Faith in the archaeological possibilities of the Jeddito Valley led Mr. Claflin to instigate an extensive reconnaissance trip in 1935 which was followed by four seasons of intensive excavation.[2]

The Claflin family became an integral part of the Awatovi field crew and the social life of the camp, joining such well-known scholars as Watson Smith, Burt and Hattie Cosgrove, Jo and Evelyn Brew, and Richard Woodbury in a remarkable archaeological endeavor. Bill, Helen, and the children all took part in the excavations, with the older Claflin children serving as project assistants and conducting some of the artifact analysis. Certainly one of the more unusual "artifacts" to come out of the Awatovi Expedition was a miniature, three-dimensional diorama portraying Bill Claflin,

Jo Brew, and an unidentified Hopi worker at Awatovi that Harvard diorama-maker Ted Pitman made for display in Bill Claflin's private museum. This charming piece is now in the collections of the Peabody Museum.[3] Bill's participation in archaeological fieldwork declined after the Second World War, but he remained a strong supporter of the Peabody Museum for the rest of his life. This patronage culminated in his 1982 bequest to the museum of his extraordinary private collection of Native American art.

From the 1910s through the late 1930s, Bill Claflin amassed a remarkable collection of some thirty-five thousand archaeological and ethnographic objects from North and Central America, Europe, and the Mediterranean region. The twenties and thirties witnessed his most intensive period of acquisition and his evolution into an astute and discriminating collector. (In addition to anthropological materials, Claflin also collected fine paintings, historic signatures, and old letters.) His thirty-three thousand archaeological holdings include twenty thousand projectile points and a variety of artifacts from such diverse regions of the world as Stallings Island, Georgia, the American Southwest, the Panamanian site of Coclé (Sitio Conte), Egypt, Rome, and the Swiss lake dwellings.

Bill Claflin's ethnological collection numbers around two thousand objects and focuses almost entirely on North America. Emphasizing the material culture of the Southwest and the Great Plains, the collection also contains materials from the Northeast, Great Lakes, Great Basin, California, Northwest Coast, Subarctic, and Arctic. It is especially rich in Southwestern woven textiles and Plains Indian hide and leather garments, reflecting Claflin's keen interest in traditional Native dress. It also includes baskets, household utensils, weapons, and ceremonial paraphernalia.

Claflin collected some of these objects directly from their Native owners or makers and others from commercial dealers or shops. Most, however, he acquired by purchasing older collections assembled by other collectors. Much of Claflin's Plains Indian and Southwestern material, for example, came from a collection made between 1878 and 1893 by a William Morris of Omaha, Nebraska, who in turn had acquired a collection made by General George Crook. In some cases Claflin acquired an individual's entire collection, and in others, just a part. Most of these collections he purchased firsthand from the descendants of their collectors. It is probably no coincidence that he acquired most of these items during the Great Depression, when

people were more inclined—and under greater economic pressure—to part with their family heirlooms.

What makes William Claflin's ethnological collection so interesting from a historical point of view is the great care he took in cataloguing his acquisitions. He entered each new object into an ethnological catalogue ledger in which he recorded information about ethnic affiliation, date of manufacture, description, and collection source. His Southwestern blanket catalogue was even more detailed, containing information about cultural affiliation, garment type, design, weave structure, dimensions, thread counts, yarns and dyes, and collection history as well as his personal feelings and observations about each piece. He even made watercolor renderings of some of the textiles. Clearly, for Bill Claflin, the care and maintenance of his collection was a labor of love.

Two pages from Bill Claflin's blanket catalogue, showing detailed catalogue entry and watercolor drawing for one of his Navajo textiles. This blanket is illustrated in plate 8. Peabody Museum, Harvard University, photos N36063 and N36064. Hillel S. Burger, photographer.

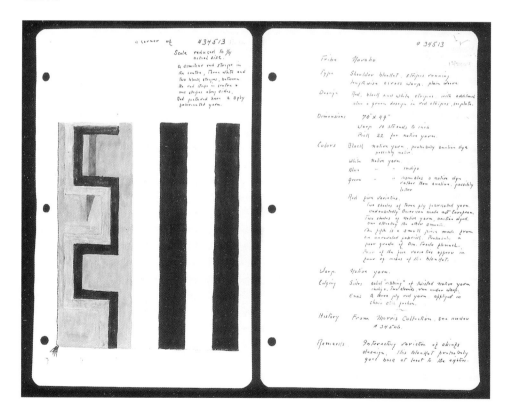

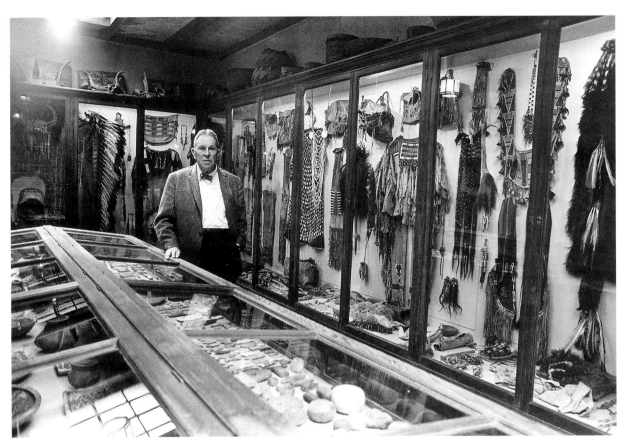

Bill Claflin in his private museum in Belmont, Massachusetts, in the early 1970s. Courtesy Judith Parker, photographer.

To exhibit and store his extensive collection, Bill Claflin maintained his own private museum, a one-story T-shaped building located behind the family home in Belmont, Massachusetts. Boasting wall-to-wall display cases of wood and glass, the museum was modeled after the galleries at the Peabody. It was open by appointment and entertained visitors from all over the world. The Claflins particularly relished the visits of the fifth-grade classes from the nearby public schools, when Bill and Helen would lead the children on private tours. The children must have loved their visits, too, because at the end of each tour they customarily received some ice cream and an arrowhead.[4]

Long before William Claflin's Southwestern textile collection came to the Peabody Museum, its existence was known to serious scholars and collectors of Navajo weaving. Charles Amsden illustrated several of Claflin's Navajo blankets in his monumental 1934 study, *Navaho Weaving*. It is likely that Amsden was well acquainted with Claflin and his collection, because Amsden, too, participated in the Peabody Museum's fieldwork in northern Arizona and was a student of A. V. Kidder's at Harvard. Amsden's book brought Claflin's textile collection to the national fore, placing it on a par with collections at the Southwest Museum, the Laboratory of Anthropology, the Heye Foundation, and the U.S. National Museum (Smithsonian). When Mary Hunt Kahlenberg and Anthony Berlant organized the first major exhibition of Navajo blankets at the Los Angeles County Museum of Art in the early 1970s, they included five of Bill Claflin's textiles in their catalogue, elevating the collection to further national attention. In the early 1970s, Southwestern textile scholar Joe Ben Wheat also visited Claflin's museum to study his collection. Several of Claflin's pieces are featured in a recent book by Wheat, published posthumously.[5]

Despite casual knowledge of William Claflin's collection by scholars and collectors, it has remained surprisingly little known to the general public. Only a fraction of it has been published or publicly displayed. As part of an effort to increase the visibility of its Southwestern textile holdings, the Peabody Museum in 2000 and 2001 sponsored an evaluation of the collection and mounted a series of short-term exhibitions of Navajo and Pueblo textiles. One of these exhibits, curated by Tony Berlant, highlighted pieces in the Claflin collection, allowing museum visitors to appreciate firsthand a selection of these exquisite weavings. The purpose of this book is to make this collection known on a worldwide scale and to bring William Claflin, the people he collected from, and these many wonderful weavings the attention and recognition they deserve.

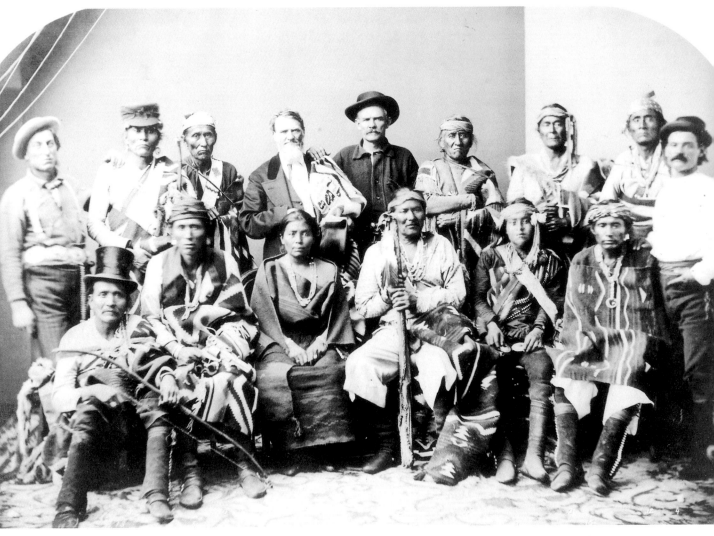

Indian agent W. F. M. Arny and the Navajo delegation to Washington, D.C., 1874. Left to right, front row: Carnero Mucho, Mariano, Juanita Paltito (Manuelito's wife), Manuelito, Manuelito Segundo, and Tiene-su-se; standing: "Wild" Hank Sharp, Ganado Mucho, Barbas Hueros, Agent Arny, Kentucky Mountain Bill (interpreter), Cabra Negra, Cayatanita, Narbona Primero, and Jesus Arviso (interpreter). The blanket worn by Arny bears the dates 1776 and 1876(?) and the initials U.S.; it may have been woven for the United States Centennial. Courtesy Denver Public Library, Western History Collection, call number z-2299. Charles M. Bell, photographer.

WILLIAM CLAFLIN'S COLLECTORS

ONE OF THE THINGS that makes Bill Claflin's collection so fascinating from a historical point of view is the stories it has to tell. Claflin's appreciation for the power of this information is reflected in the great pains he took to record the histories of those who possessed the textiles before him. Military officers, Indian agents, a Ute Indian leader, a schoolteacher, a well-known artist, and other early Euro-American visitors to the Southwest were all collectors of textiles that found their way into Claflin's museum. Here I highlight the lives of some of the people who collected these weavings and the ways in which Claflin acquired their pieces. To provide some perspective on the evolution of the Claflin collection, I discuss these people in the approximate order in which their collections were received. I conclude the chapter with a brief look at the collecting activities of Bill Claflin himself.

FRANK CLARK

According to information that Frank Clark supplied to Claflin, Clark was employed on the Shoshone Reservation in Utah during the mid-1870s. The exact nature of his employment is unknown; Claflin did not record this information in his catalogue, and Clark's name does not appear in the reports of the commissioner of Indian affairs in conjunction with either the Uintah Utes of Utah or the Shoshone Indians of Wyoming for the period in question.[6] Nonetheless, sometime during his time in the West, Clark collected a lovely Navajo woman's shoulder blanket (pl. 11 and cover), a style that was very popular among the Utes. Bill Claflin acquired the blanket directly from Clark in 1921 while Clark was living in Augusta, Georgia.

STERLING PRICE AND ANDREW DASBURG

In 1927 Claflin purchased a Navajo woman's two-piece dress (pl. 4, inset) from Taos artist Andrew Dasburg (1887–1979). Born in Paris, Dasburg came to New Mexico in 1918 and spent the rest of his life in Taos. When he sold Claflin the blanket, Dasburg informed him that the dress had come from the collection of former New Mexico governor Sterling Price.

Sterling Price (1807–1867) came to New Mexico with the American occupation in 1846, during the Mexican-American War, and remained in the territory until the end of the war in 1848. After General Stephen W. Kearny departed New Mexico, Price was left in charge of the American troops in Santa Fe. In 1847 Price and his Second Regiment of Missouri Mounted Volunteers helped crush the Taos rebellion, an uprising of Hispanos and Pueblo Indians that resulted in the killing of Governor Charles Bent and several other Americans in Taos, New Mexico. Promoted to brigadier general, Price served as military governor of New Mexico, with Donaciano Vigil as civil governor, until the Treaty of Guadalupe Hidalgo was signed in 1848. After the signing, Price left New Mexico and returned to his native Missouri, later serving as governor of that state (1853–1857) and as a Confederate general during the Civil War.[7]

The Sterling Price Museum in Keytesville, Missouri, contains some of Price's military artifacts and family furnishings, but no Southwestern textiles. It is unknown whether Price collected any other Southwestern weavings during his short but eventful tenure in New Mexico.

HENRY F. BOND AND CHIEF OURAY

Henry F. Bond, a Harvard graduate and Unitarian minister from Boston, served as the United States Indian agent for the Ute Indians at Los Pinos Agency near present-day Montrose in southwestern Colorado between 1874 and 1876. Famed frontier photographer William Henry Jackson visited Los Pinos Agency in August 1874 as a member of the Hayden survey and in his autobiography described meeting Bond. It was Bond who introduced Jackson to the renowned Ute leader Chief Ouray. One evening during his brief visit, Jackson set up his camera on the porch of Bond's house and took photographs of Mr. and Mrs. Bond and of Chief Ouray and his wife, Chipeta. If the images of the Bonds were ever developed, their location is still unknown.[8]

Sidney Jocknick, a cowboy who spent the winter of 1875–1876 at Los Pinos Agency, described the Bonds as "highly cultured people, whole-souled and cordial." So cultured were they that they established "a literary, debating, and dramatic club" at the agency that winter. Unfortunately, problems arose with Henry Bond's tenure following an incident in which two hundred head of cattle brought down from the high country strayed back home, leaving the cattle count short. The government replaced the cattle but assessed their cost against Bond's salary. As a result, Bond was asked to resign his post in 1876. According to Jocknick, this dismissal was not nearly as distressing as one might suppose: "He accepted his demit with a good grace, for, he was heartily tired of being the Ute agent any longer, and hailed with delight an opportunity so well timed with his feelings in

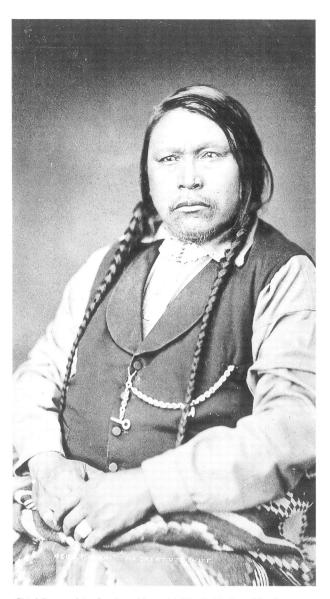

Chief Ouray of the Southern Utes with Navajo blanket, 1882. Courtesy National Anthropological Archives, Smithsonian Institution, neg. 46785E. William Henry Jackson (?), photographer.

which to abdicate his post gracefully." It was at the time of their departure from Los Pinos Agency that the Bonds allegedly acquired the serape shown in plate 13.

In a letter to Claflin written about 1929, J. M. Harnden, Henry Bond's nephew, related that the Bonds had obtained this blanket in the following manner (Harnden's original punctuation retained):

> At the time my aunt and uncle were on the Ute Reservation, Ouray was head chief and the blanket in question belonged to him. My aunt told me that when they left for the east the first part of the journey was a long buckboard ride and Ouray came to say "good by." She had an old cotton umbrella which Ouray wanted, he was very insistent. Finally with a regal gesture he took off this beautiful blanket & tossed it into the buckboard with the result he got the umbrella.

Henry Bond is known to have collected at least three other Navajo blankets from Southern Utes during his time in southwestern Colorado. None of those, however, has documentation linking it to Chief Ouray. In 1929 Bill Claflin purchased four of Henry Bond's textiles from Bond's nephew—the two serapes shown in plates 13 and 14 and two third-phase chief blankets, both of which Claflin gave away as gifts prior to his death.[9]

From early writings and photographs by Euro-American visitors and from collections such as Bond's, it is clear that Ute leaders of the late nineteenth century were well stocked with Navajo blankets. Such blankets served not only as symbols of wealth and prestige but also as important commodities of trade and gift giving. William Henry Jackson described the couch in Chief Ouray's adobe home as being covered with Navajo blankets, and he mentioned having bought "two or three" blankets from Chief Ouray and another Ute chief, Tush-a-qui-not, or "Peah." Jackson's assistant, Ernest Ingersoll, also purchased one from Peah for the sum of $12. Evidently, there were plenty of Navajo blankets to go around that particular year. Fortunately, some of the splendid blankets formerly owned by Chief Ouray have found their way into museum collections.[10]

WILLIAM STANLEY HATCH

William Stanley Hatch (1819–?) grew up in Springfield, Massachusetts, and later moved to Cincinnati, Ohio. In 1859 he took a mule train to Santa Fe, where he met Kit Carson. He traveled north to Colorado the following year and in 1863 organized a military company in Denver that subsequently joined General Brown's regiment. Accompanied by the noted Indian scout Jim Baker, the company was sent down the Platte River by General Evans to "quiet the Indians." It was stationed at old Fort St. Vrain for a time, then disbanded after returning to Denver. Hatch returned to Cincinnati in 1867. His date of death is unknown, but he was still living in Ohio in 1890 when a short biography of him was published.[11]

While in Colorado, Hatch acquired a beautiful second-phase chief blanket (pl. 6), which he sent to a Massachusetts friend, Edmund Trowbridge. Bill Claflin purchased this blanket from a relative of Trowbridge's in 1929.

WILLIAM R. MORRIS AND GEORGE CROOK

In light of the size and significance of William Morris's Plains Indian collection, it is surprising that Claflin did not have more to say in his ethnological catalogue about Morris's personal life. He did reveal that Morris lived in Omaha, Nebraska, and that he compiled his collection between 1878 and 1893. He also wrote that during this time Morris made several trips to the Great Plains, befriending many U.S. Army officers. Unfortunately, we still know little about how and where Morris acquired his collection of approximately seven hundred pieces.

Recent research by the Peabody Museum suggests that this William Morris may be the same person as the W. R. Morris who was a founding partner in an Omaha law firm and who practiced law there between 1878 and 1899.[12] This research also suggests that Morris purchased some items in his collection from a Sheridan, Wyoming, Indian art dealer named Herbert A. Coffeen, who dealt in high-end Native American objects, including Navajo blankets. At this point, however, we have no concrete proof that any of Morris's Navajo textiles came from this source.

In the early 1890s Morris added to his own collection by purchasing that of the famous military leader General George Crook (1829–1890), acquiring the collection

from Crook's widow soon after the general's death. A decorated officer in the Civil War, Crook went to Arizona in 1871 and waged a vigorous campaign against the Apaches until 1875, when he left to assume command of the Department of the Platte in the northern Great Plains. From 1875 to 1882 Crook played a major role in the Plains Indian wars. He then returned to Arizona in 1882, pursuing Apache groups deep into northern Mexico. In 1887 Crook was transferred to the Uintah and Ouray Reservations in Utah, and after a short stint in Chicago, he returned to the Plains for one last time as a member of the Sioux Commission.[13]

Crook accumulated his collection of Southwestern and Plains Indian materials between 1871 and 1889, collecting from the San Carlos Apaches, Crows, Sioux, Cheyennes, and Utes. His military campaigns did not directly involve the Navajos, so it seems likely that he acquired many of his Southwestern weavings from traders or non-Navajo Native people (including Apaches) who had obtained their blankets through the Navajo trade.[14]

Fort Omaha became the headquarters of the Department of the Platte in 1878. The following year Crook built a house in Omaha, which now serves as the Crook Museum. It is quite possible that Morris and Crook knew each other in Omaha and were familiar with each other's collections. For several years Morris's collection (now augmented with Crook's materials) was displayed at the Omaha Public Library. In 1930, Claflin purchased the collection from Morris's widow for the then-fabulous sum of $7,000.

Unfortunately, Morris did not catalogue his Navajo blankets. He indicated in his records that some of the blankets were originally part of Crook's collection but failed to specify which ones. Claflin believed that Morris had obtained most of his self-acquired blankets from Plains Indian sources and had never visited the Southwest himself. We are left to speculate which blankets were collected by Morris and Crook on the Great Plains and which were acquired by Crook in the Southwest.

The ten textiles from the Morris–Crook collection now at the Peabody Museum include a rare Navajo first-phase chief blanket (pl. 5), a Navajo second-phase chief blanket (985-27-10/58886, not illustrated), a Navajo modified second-phase chief blanket (pl. 8), a Navajo fourth-phase chief blanket (pl. 10), a Navajo wedge-weave blanket (pl. 23), a Navajo Germantown blanket (985-27-10/58887, not illustrated),

a Navajo or Pueblo banded blanket (985-27-10/58891, not illustrated), a Zuni or Navajo "fancy manta" (pl. 11, inset), a Navajo or Zuni serape (pl. 17), and an unusual Navajo saddle throw made with flannel rag wefts (985-27-10/58892, not illustrated).

CHARLES ATHERTON HARTWELL

Charles A. Hartwell (1841–1876) was a military officer with a successful, if relatively brief, career in the United States Army. Born in South Natick, Massachusetts, he enlisted as a private in the Seventh New York Regiment during the Civil War, eventually achieving the positions of adjutant and first lieutenant to the First Battalion. He was severely wounded at the battle of Gaines' Mill. In 1863 or 1864 he was promoted to colonel and assumed command of the newly formed Fifth Corps d'Afrique Infantry in New Orleans, Louisiana. He served as a white officer with the United States Colored Troops and later with the Tenth Regiment of the U.S. Colored Heavy Artillery until his discharge from that unit in 1867. Sometime around 1869, his military career led him to the Southwest.[15]

A letter by Hartwell's son quoted in Claflin's blanket catalogue states that his father acquired the two Late Classic serapes now in the Claflin collection (pls. 15 and 16) while on duty in the Southwest. "The blankets were acquired by my father between 1869 and 1873. . . . The old headquarters of the Navajo Reservation was at Ft. Defiance. . . . These blankets were some of those given to my father by Navajo chiefs while there." Although this letter suggests that Captain Hartwell spent time at Fort Defiance, my research indicates that he was stationed not there but at the nearby military post of Fort Wingate. After the Navajos' return from their incarceration at Fort Sumner, or Bosque Redondo, in 1868, Fort Defiance served as the Navajo agency and was no longer a military fort.

The exact dates of Hartwell's tour of duty at Fort Wingate are unknown, but he was definitely present on August 23, 1875, when a group of Navajos took over the Fort Defiance agency while their Indian agent, W. F. M. Arny, was in Santa Fe. The regular commanding officer, Major William R. Price, was away from Fort Wingate that day, and Captain Hartwell was in command. It was Hartwell who answered the message of distress from Arny's representative at the agency.[16]

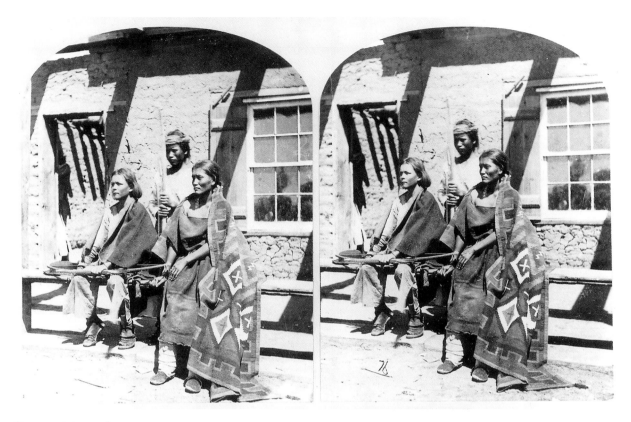

Stereoscopic image of an unidentified Navajo woman and two Navajo boys at Fort Defiance, Arizona, 1873. By this time the fort served as the Navajo Indian agency. Peabody Museum, Harvard University, photo H4275. Timothy O'Sullivan, photographer.

Bill Claflin's catalogue entry states that Charles Hartwell died in 1876, only a year after this incident at Fort Defiance. Information from another source indicates that Hartwell died in 1876 in Castorville, Texas, while on sick leave from the army and en route to his Massachusetts home.[17] The cause of his death is unknown. Bill Claflin acquired the two Navajo textiles from Hartwell's grandson, Alfred, probably in the early 1930s. Claflin did not explain his relationship with Hartwell's grandson, but they might have shared a Harvard connection, given that multiple generations of the Hartwell family attended that university.

ELIZA HOSMER

Eliza Hosmer (1833–?) is at once the most elusive and the most intriguing of Claflin's collectors. Raised in Concord, Massachusetts, she was the seventh of ten children born to Edmund and Sally Pierce Hosmer. Her family's social circle brought her into contact with the likes of Ralph Waldo Emerson, the Alcott family, and Henry David Thoreau, all neighbors and family friends. Eliza's father, Edmund Hosmer, was "the philosophic farmer" to whom Thoreau referred in *Walden* and was one of the people who helped Thoreau raise his cabin at Walden Pond. Thoreau spent many Sunday evenings at the Hosmer home, and the Hosmer children were frequent visitors to Thoreau's cabin, where they were exposed to long discussions on mythology and philosophy. Later in life, in the 1890s, Eliza Hosmer served as an informant about Thoreau's life to Dr. Samuel A. Jones, a Michigan homeopathic physician and eminent Thoreau scholar, who treated her for malaria. Eliza is credited with initiating the many years of important correspondence between Jones and her Concord relative Alfred Winslow Hosmer.[18]

Bill Claflin included an extensive account of Eliza Hosmer's life in his blanket catalogue. It seems to have been based largely on information supplied by her niece, Anne Lauriat (Mrs. Robert) Read, from whom Claflin purchased several of Hosmer's Navajo blankets. Claflin relates that Eliza Hosmer was a schoolteacher and that she lost her sense of hearing at the age of thirty-three. This forced her to resign her position as principal of a high school in Ohio. She moved to Medford, Massachusetts, where she lived until 1872, when she went to Missouri to tutor a young cousin. According to Claflin, sometime around the middle 1870s she obtained a teaching position at the Ramona Indian School in Santa Fe. In Claflin's words:

> For many years she devoted her time to teaching Indians. Moving about from place to place, mostly confining her attention to the Navahoes. Soon after her arrival in the Southwest Navaho blankets began to appear as gifts to her sisters and cousins. Likewise, according to her niece Mrs. Anne L. Read, she kept many for her own "pleasure." From time to time she would present a blanket from her own collection to one of the family.

Unfortunately, we have been unable to substantiate much of Claflin's fascinating and romantic account of Eliza Hosmer's life.[19] Instead, our research suggests that Hosmer did not travel to the Southwest until the 1890s. The precursor to what would become the Ramona School opened in 1885 as an Indian industrial boarding school operated by the Indian Department of the University of New Mexico in Santa Fe. After the university moved to Albuquerque in the late 1880s, administration of the Indian school was assumed by the American Missionary Association (AMA). By this time the school was known as the Ramona Industrial School for Indian Girls of the Southwest, or, more commonly, the Ramona School, named after the novel by Helen Hunt Jackson. From 1889 to 1892, the AMA operated the Ramona School under contract with the U.S. government. In 1893 administration of the school passed to the trustees of the University of New Mexico, who managed it until its closure around 1895. During its short life, the Ramona School provided instruction primarily to Jicarilla Apache students and some Mescalero Apache and Navajo children. It was also one of the Indian schools that took students to the 1893 World's Columbian Exposition in Chicago to display its teaching techniques.[20]

Bill Claflin stated that Eliza Hosmer began her involvement with the Ramona School in the mid–1870s, but the school did not even exist until the late 1880s. There are other problems with his account as well. Although he indicates that Hosmer was involved with the Ramona School for many years, our research has uncovered only one possible reference to her presence there. This reference dates to 1894, when a report identifies a "Miss Hosmer" as the assistant matron of the school. Based on Claflin's account that Hosmer was affiliated with the Ramona School at some point in time, it seems quite likely that this "Miss Hosmer" was Eliza Hosmer, but this has yet to be substantiated. So far, this is the only known documentary evidence linking Eliza Hosmer with the Southwest. Her name does not appear on the lists of teachers for any of the government–operated Indian schools in New Mexico or on the Navajo Reservation, nor is she listed as a government employee in New Mexico or at the Navajo agency.[21] Clearly, we still have much to learn about her life.

What we do know about Eliza Hosmer is this. She was an amateur botanist and recognized naturalist who studied the local flora of the Concord area and later other

regions of the United States where she lived. Following the death of Henry Thoreau in 1862, it was Eliza Hosmer who acquired his herbarium of pressed and mounted flowers, ferns, and leaves from his sister Sophia. In the 1870s, Hosmer is known to have sent plant specimens from different parts of the country to another avocational botanist, George Davenport, for his herbarium in Medford, Massachusetts. That this was more than a casual hobby to Hosmer is indicated by the inclusion of her name in the national directory of American naturalists for several years.[22]

We also know that Eliza Hosmer traveled widely throughout the United States. Most of her travels involved extended stays with the families of her brothers and sisters, where she tutored her nieces and nephews. Although Claflin wrote that she lost her sense of hearing at age thirty-three, she evidently retained enough hearing to continue with her tutoring activities. At some point—we do not know when—she contracted malaria, which forced her to spend most of the year away from the "malarial atmosphere" of Concord. This raises the possibility that malaria was the cause of her hearing loss. Between 1875 and 1893 she resided with various siblings and their families in New Jersey, Illinois, Missouri, and Michigan, returning to Concord between visits.[23] Around 1900 she moved to Los Angeles, California, presumably to be near her niece, Anne Lauriat Read. It is in Los Angeles that we lose track of Eliza Hosmer's life. Claflin's catalogue states that she lived to be over ninety years old, but a listing of family members in her sister Jane's 1922 will indicates that Eliza was no longer living at that time. We have yet to learn where she spent her final years.

At some point in her life, Eliza Hosmer began to amass a remarkable collection of Navajo textiles, eventually numbering between forty and fifty pieces. Unfortunately, we are still in the dark about where, when, and how she acquired these blankets. She might have collected some textiles while working at the Ramona School, as Claflin suggested, perhaps receiving them as gifts from the families of her Jicarilla Apache students. However, the collection seems much too large, and her time in New Mexico too short, for the entire assemblage to have been acquired in this manner. Rather, it seems more likely that she purchased her pieces through Indian art dealers in Santa Fe, Los Angeles, or Chicago. Following this trail is the next step in our research.

One thing is clear. Eliza Hosmer had an incredible eye for textiles. In Bill Claflin's

words: "That Eliza Hosmer knew Navaho blankets is obvious by the quality of her selections. Mrs. Read told me she remembered her aunt saying after returning from a trip to California that she had seen Charles F. Lummis's collection of blankets [now at the Southwest Museum] and that in her opinion her collection was superior to his."

Upon her death, many of Eliza Hosmer's Navajo blankets went to her sister Abby Hosmer, of Concord. After Abby's death in 1932, Claflin contacted the executor of her estate and arranged to purchase twelve of Eliza's blankets. Around the same time he also acquired four of her blankets from Anne Lauriat Read, who had received them as gifts from her aunt. The Peabody Museum collection contains eleven of the sixteen Hosmer pieces originally owned by Bill Claflin: two chief blankets (pls. 7 and 9), six Late Classic serapes (pls. 18–20 and 985-27-10/58900, 985-27-10/58905, and 985-27-10/58910, not illustrated), two Transitional blankets (pl. 21 and 985-27-10/58909, not illustrated), and a woman's two-piece dress (985-27-10/58902, not illustrated), all dating to the period 1860–1890.[24]

Eliza Hosmer reportedly also gave blankets to some of her other nieces, nephews, and friends, but the whereabouts of these are unknown. According to Claflin, much of Hosmer's collection had already been sold off and dispersed by family members before he began acquiring her blankets. If any have survived with their documentation still intact, we have yet to learn of their existence, but they must be out there somewhere. Perhaps one day letters or other records will come to light to tell us more about the collecting activities of Eliza Hosmer. Until then, her superb Navajo textile collection stands as her lasting legacy.

W. F. M. ARNY AND THE CORNELIUS COSGROVE FAMILY

William Frederick Milton Arny (1813–1881) enjoyed a colorful government career in the Southwest. He began it in 1861 with the United States Indian Service, assuming Kit Carson's former position as Indian agent to the Utes and Jicarilla Apaches. From 1862 to 1867 he served as secretary of New Mexico Territory, and in 1866 he briefly was acting governor. In 1867 he returned to his position as Indian agent to the Utes and Apaches, and in 1870 he was appointed special agent for the Indians of New Mexico, working primarily among the Pueblo villages. In 1873 Arny accepted the

position of Indian agent to the Navajos at Fort Defiance, Arizona. In the fall of 1875 he retired amid controversy following a takeover of the agency by a group of Navajos while he was away from the post. After leaving government service, Arny retired to Santa Fe, where he spent the rest of his life.[25]

One of Arny's more prominent accomplishments as Indian agent was organizing a delegation of Navajo leaders to Washington, D.C., in 1874. The trip lasted nearly three months and entailed visits not only to the nation's capital but also to New York, Providence, and Boston. Departing for the East in mid-November 1874, the group stopped at several cities along the way to participate in some well-orchestrated public events. One of these was in Santa Fe, where Arny arranged for a public display of Navajo crafts in the territorial secretary's office. The exhibit included pottery, baskets, and woven saddle blankets as well as a huge red, white, and blue blanket woven especially for the United States Centennial. Arny seems to be wearing this blanket in the official portrait of the Navajo delegation taken in Washington, D.C. (see p. 12).

Arny is best known for his contributions to Indian education, but he was also a strong supporter of indigenous crafts, especially Navajo weaving. In 1862, while attending a New Year's Day reception at the White House, he presented Mary Todd Lincoln with a lovely Navajo blanket. His own office in Santa Fe was filled with Indian crafts, which he eventually donated to the Smithsonian Institution.[26]

Arny regarded weaving as a source of economic independence for the Navajo people and did what he could to promote the craft. In his 1874 annual report to the commissioner of Indian affairs, he praised the Navajos' skillful manufacture of blankets, silk work, and baskets, adding that "during the past year I have assisted them all I could, so as to increase the quantity of these articles and encourage them to make them for sale." It was with the goal of "making the Indians self-sustaining" that Arny purchased several spinning wheels and floor looms during his trip to the East Coast and had them shipped back to the Fort Defiance Agency in Arizona, hiring people to set up the machinery and provide instruction in its use. Despite Arny's good intentions, the experiment failed. In the words of Alex G. Irvine, Arny's successor at the Navajo agency, "the hand-looms purchased and set up for them two years ago have not proved to be as great a success as was hoped for at that time. The Navajoes seem to

prefer their own way of weaving blankets."[27] In retrospect, we are glad they did.

While living in Santa Fe, Arny befriended the Cornelius ("Cos") Cosgrove family. Cosgrove had moved west in 1859 and ran a stage, mail, and freight business between Santa Fe and Mesilla, New Mexico, and Tucson, Arizona. In 1870 he married Amanda Bennett and adopted her young daughter, Katherine (Kitty). In 1875, the couple had a son, Cornelius Burton. In later years this son, better known as Burt or C. B., and his wife, Hattie, were prominent archaeologists with the Peabody Museum, best recognized for their work on sites of the Mimbres culture in New Mexico.[28] Their archaeological careers intertwined with that of William Claflin Jr. at Stallings Island and Awatovi Pueblo, and the two families became close friends.

Sometime around 1874, Arny gave three Navajo weavings to Amanda and Kitty Cosgrove. According to information supplied by Burt and Kitty Cosgrove, Arny acquired the serapes near old Fort Wingate about 1874. One blanket (pl. 19, inset) is now part of the Claflin collection at the Peabody Museum. The other two, a Late Classic serape and a smaller fringed saddle blanket, are in the collections of the Laboratory of Anthropology at the Museum of Indian Arts and Culture in Santa Fe. Another blanket collected by Arny is in the collections of the former U.S. National Museum, now the National Museum of Natural History, Smithsonian Institution.[29]

Kitty Cosgrove related the history of her blanket in a December 1935 letter to Claflin. She said that Arny had given her the blanket sometime around 1874 and that soon afterward she sent it to her younger cousin, George Curtis, then living on a farm in Independence, Iowa. A dozen years later, Kitty's cousin Lizzie was visiting the old family farm and saw the blanket hanging from a nail in the barn, "dirty as it could be & moth eaten as it is." She asked the farmer if she could have it and he readily complied, saying, "Why of course, it's only a rag." Lizzie took the blanket home, washed it in Ivory soap flakes, and took it to the Fred Harvey store in Albuquerque. The staff offered her $200 on the spot or trade for any new blanket in their collection, but Lizzie declined and took the blanket home. Years later, knowing of Bill Claflin's interest in Navajo textiles, Kitty Cosgrove contacted her cousin and requested the blanket's return. Upon receiving it, she gave it to her brother, Burt, who sold it to Bill Claflin on her behalf in 1935.

Rowland Gibson Hazard II (1855–1918) was a Rhode Island businessman, philan-
thropist, and collector and the grandson of noted essayist Rowland Gibson Hazard.
Rowland Hazard II grew up in the village of Peace Dale, Rhode Island, which was
named after his great-grandmother, Mary Peace Hazard. He enjoyed a prosperous
career in the family-owned textile mills, the Peace Dale Manufacturing Company,
becoming its president in 1898. As a young man he nurtured a strong interest in
ornithology and preindustrial technology and began collecting Native American arti-
facts, particularly projectile points and other stone tools. In 1892 the Hazard family
funded a cultural center for the local community, within which was included an
"arrowhead room," designed for the exhibition of Indian artifacts. Many of the stone
tools displayed in this room came from Hazard's collection, augmented by artifacts
donated by other local collectors. Over the years the collection grew to encompass a
diverse assortment of artifacts from all over the world; it eventually outgrew its facili-
ty. In 1930 the collection was moved into its present quarters in the historic Peace
Dale Office Building, where it is now known as the Museum of Primitive Art and
Culture.[30]

Hazard's work in the family textile business engendered in him a special interest in
woven artifacts. He amassed a strong collection of Native American baskets, as well as
some Southwestern weavings. Hazard and his wife spent their summers in Santa
Barbara, California, and may have acquired some of their Southwestern materials
while in the West.[31] Hazard is also known to have purchased some of his artifacts from
the Fred Harvey Company.

In the 1930s a Late Classic/Transitional serape (pl. 22) formerly owned by
Rowland Gibson Hazard II found its way into Bill Claflin's collection under rather
fortuitous circumstances. As Claflin related in his catalogue, one day archaeologist
A. V. Kidder was walking by one of the men's dormitories at Harvard when he spied
a Navajo blanket hanging from a window. Intrigued, he tracked down its owner, a
Mr. R. G. H. Sturgis of Peace Dale, Rhode Island. He then put Sturgis in contact
with William Claflin, who purchased the blanket for $300. Sturgis told Claflin that
the blanket had once belonged to his grandfather, Rowland Gibson Hazard II.

OTHER COLLECTORS

The Claflin collection also contains pieces from collectors about whom very little is known. One of these is a Mrs. D. F. Craig, who sold Claflin a blanket (985-27-10/58875, not illustrated) that had been in her sister's family since the 1880s. Mrs. Craig also collected pieces for Claflin while her husband was stationed at Fort Sill, Oklahoma, in the early 1920s. None of the latter are known to be in the Claflin collection at the Peabody Museum. Another of Claflin's sources was a Mrs. John Lowe, who collected a Navajo woman's two-piece dress (985-27-10/58914, not illustrated) and a Navajo Transitional rug (985-27-10/58915, not illustrated) at a saddle shop in Telluride, Colorado, in 1894. According to Mrs. Lowe, the shop was piled high with blankets brought in by the local Indians for sale or trade. She did not say whether these blankets were delivered by Navajos or Utes.

WILLIAM H. CLAFLIN JR.

Last but not least, William Claflin himself directly acquired a number of pieces in his collection. Some of these he purchased during his trips to the Southwest. His Pueblo acquisitions included two Hopi embroidered and painted kilts (985-27-10/58872 and 985-27-10/59221, not illustrated), purchased during his first visit to the Hopi Mesas in August 1912, and a prizewinning Hopi man's plaid wearing blanket (pl. 3) acquired sometime around 1937, perhaps at the Hopi Craftsman Exhibition at the Museum of Northern Arizona in Flagstaff. He purchased a Zuni embroidered woolen manta (pl. 2) and an older Zuni striped woolen blanket (985-27-10/58899, not illustrated) from Zuni trader C. G. Wallace in the 1930s.

Claflin also bought a number of Navajo blankets, rugs, and runners during his trips to the Southwest, many of them new at the time of purchase. These he seems to have regarded more as decorative objects than as museum pieces, as he did not enter them into his blanket catalogue but used them instead to adorn his museum and home. As a result, we know relatively little about his acquisition of these more recent Navajo weavings, now nearly a century old.

From the few records that do exist, we know that Claflin bought two Navajo textiles at the Tuba City Trading Post in 1913 and another at John Wetherill's trading post in

Kayenta in 1923. Because these records provide no descriptions of the pieces, it is unknown whether they are now part of the Peabody collection. The records also reveal that Claflin purchased two textiles in the mid-1920s from Cozy McSparron's trading post in Chinle, one an older piece and the other a revival weaving. The revival weaving, made in the summer of 1925 and acquired by Claflin for $32, is described in his records as "a good example of the excellent work McSparon [*sic*] is doing of getting the Navajos to weave old style blankets." The older weaving was acquired by McSparron for use as a model in his revival efforts. Again, neither one is physically described in Claflin's records, so it is unknown whether either made its way into the Peabody Museum collections. Claflin also purchased some of his textiles directly from dealers, including the Fred Harvey Company in Albuquerque and a Santa Fe dealer named Collins. Always on the lookout for new acquisitions, he managed to turn up old Navajo and Pueblo textiles in curio shops and pawnshops in Chicago and Boston.

The most interesting of Bill Claflin's documented purchases is the Hubbell revival blanket shown in plate 24. Claflin wrote that he bought this weaving in 1923 from a Mike Quirk (probably Kirk) of Gallup, New Mexico, who had obtained it directly from Juan Lorenzo Hubbell. I relate the full story of this blanket in the upcoming section on Hubbell revival weavings.

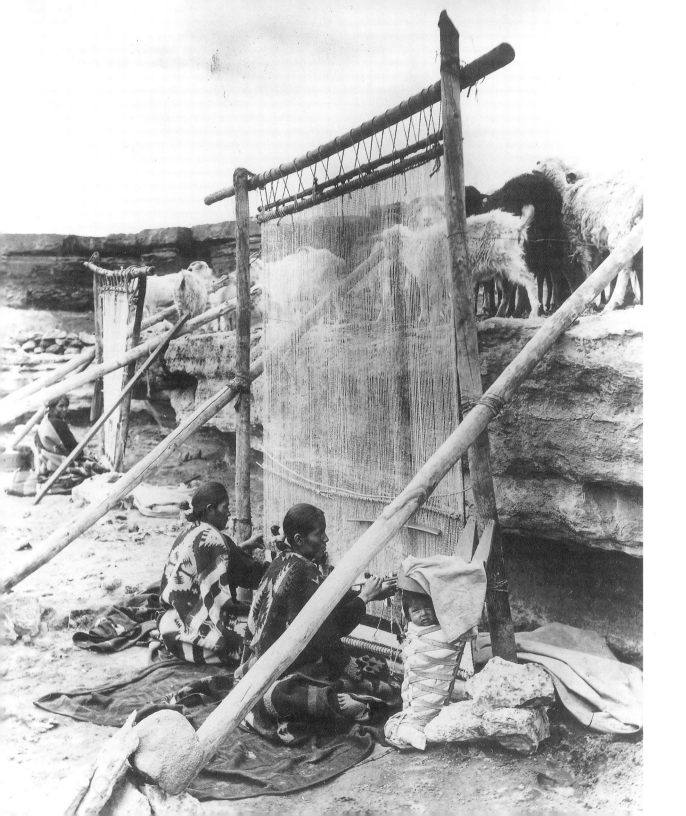

THE CLAFLIN SOUTHWESTERN
TEXTILE COLLECTION AT THE
PEABODY MUSEUM

THE PRIMARY STRENGTHS of the Claflin textile collection are its fine assortment of mid- to late nineteenth-century Navajo serapes and women's two-piece dresses and its Pueblo kilts and mantas. The collection contains eight Pueblo blankets and mantas and fifty-eight Navajo textiles, four of which may be of Pueblo rather than Navajo manufacture.[32] It also includes a Mexican or Rio Grande Hispanic serape (985-27-10/58932) that is not further discussed here. The Navajo textiles, made between 1840 and 1940, consist of nine chief-style blankets, two women's wearing blankets, six women's two-piece dresses, sixteen Classic or Late Classic serapes and saddle blankets, four Moqui-pattern blankets and rugs, nine Transitional and Early Rug–period banded blankets (including a wedge weave), four eye-dazzler rugs, a Hubbell revival rug, and seven floor rugs or novelty weavings of various regional styles (Early Crystal, Two Grey Hills, Ganado, Chinle revival, and a Gallup throw). The only major pre-1940 Navajo weaving style not represented in the Claflin collection is the pictorial style.

Three unidentified Navajo women weaving in an unknown location on the Navajo Reservation, circa 1914. The two women in the foreground are working on the same rug. Except for the rugs on the looms, all blankets in the photograph are commercial weavings, probably Pendleton blankets. Peabody Museum, Harvard University, photo N29547. William M. Pennington (?), photographer.

The assemblage also contains eight Pueblo textiles of ceremonial and everyday wear, dating between 1865 and 1940. These consist of two Hopi kilts (one painted, one embroidered), a Zuni(?) embroidered white cotton manta, a Zuni woman's black wool manta with blue embroidered borders, a Hopi woman's manta with red and blue borders ("maiden shawl"), a Hopi(?) woman's black wool manta dress with diamond-twill borders, a Hopi man's plaid wool shoulder blanket, and a Zuni banded blanket.

Thirty pieces from the collection are illustrated in the accompanying color plates. Readers wishing to know more about the technical details of these pieces will find such information in an appendix at the end of the book. An abbreviated glossary of Southwestern textile terms is also provided. Although dye analysis has not been performed on any of the pieces in the Claflin collection, I suggest possible sources of colorants in the text and appendix.

AN INTRODUCTION TO PUEBLO WEAVING

Pueblo weaving is a tradition of considerable antiquity and artistic achievement in the American Southwest, yet it is relatively unknown to the American public. Fortunately for archaeologists and textile scholars, literally thousands of textile fragments have been preserved in ancestral Pueblo cliff dwellings. These, together with mural depictions of ceremonial clothing preserved on the walls of ancient underground ceremonial chambers, called *kivas,* provide a rich picture of the diverse styles, technical proficiency, and sheer beauty of the ancient fabrics made and worn by the ancestors of the present-day Pueblo Indians: the Hopis of northern Arizona, the Zuni, Acoma, and Laguna people of western New Mexico, and the people of the Rio Grande Pueblo villages located near modern-day Albuquerque, Santa Fe, and Taos, New Mexico.[33]

Examples of Southwestern weaving date back more than twenty-five hundred years. The earliest textiles were made using a variety of finger-weave techniques, including looping, twining, and braiding (see the glossary for definitions of these and other Southwestern weaving terms). Early Southwestern weavers made extensive use of fibers from plants such as yucca, agave, Indian hemp, and milkweed, as well as human hair, bison wool, domesticated dog hair, rabbit fur, and, later, turkey feathers.

By A.D. 500 the tropical plant cotton had been introduced into southern Arizona from Mexico, and by A.D. 700 the true loom with heddles was present. (A true loom is distinguished from a simple weaving frame by the presence of a heddle mechanism that controls groups of warp threads.) By A.D. 1100, cotton and the loom had spread to the Four Corners region of present-day Arizona, New Mexico, Utah, and Colorado, where these introductions quickly became integral parts of the ancestral Pueblo, or "Anasazi," craft tradition.

Prehistoric weavers used different forms of the loom in different regions of the Greater Southwest. Whereas the backstrap loom was used in several parts of the American Southwest and throughout Mexico, a horizontal staked-out loom like that used today by the Mayo and Tarahumara Indians of northern Mexico was employed only in southern and perhaps central Arizona and farther down into Mexico. Meanwhile, a vertical loom found use only in the Four Corners region of the Colorado Plateau. This vertical loom of the ancestral Pueblos represented a localized adaptation of the basic Mesoamerican loom technology in which one loom beam

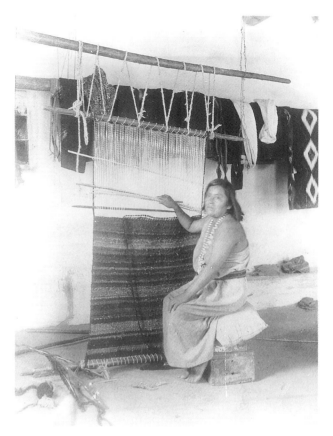

Unidentified Zuni woman weaving a blanket, circa 1900. Her manta dress appears to be of commercial cotton muslin. Peabody Museum, Harvard University, photo N32888. Adam Clark Vroman, photographer.

was attached to the floor and the other to the ceiling. This modification minimized the amount of floor space taken up by the loom and enabled ancestral Pueblo people to weave indoors during the cold winter months while still using these spaces for other purposes. It also permitted multiple looms to be set up in a room or kiva so that groups of people could weave together. This upright loom is the same one used historically by Pueblo and Navajo weavers (see above and p. 30).

Archaeological evidence suggests that indoor use of the upright loom was confined largely, though not exclusively, to kivas or religious rooms between A.D. 1300 and 1600. Because men were the ones observed weaving in kivas in the Rio Grande Valley

when the earliest Spanish colonists entered the region in 1598, it has been inferred that Pueblo men were the primary users of this upright loom technology and also the principal producers of most cotton loom-woven textiles at the time of European contact. There is some archaeological evidence to suggest that Zuni women may also have been weaving on wide upright or horizontal looms around this time. Based on ethnographic analogy, it is believed that Pueblo women were largely responsible for making most of the finger-woven textiles, for weaving on backstrap looms, and for twining most of the rabbit-fur and turkey-feather blankets. This precontact division of labor broke down to some extent during the Spanish colonial period, when Pueblo women became more involved in the weaving of tribute textiles, and continued to do so with the later shift to the American cash economy.[34]

Soon after its introduction, cotton became the fiber of choice for most loom-woven fabrics, especially the more complicated weaves. Ancient Pueblo weavers produced a diversity of simple and complex weave structures on their looms, including plain weaves, diagonal and diamond twills, supplementary weft-float weaves (brocade), and openwork fabrics such as weft-wrap openwork and gauze. They decorated cloth by a variety of methods including painting, tie dye, resist dye, self-patterning (stripes, checks, openwork), and the addition of colored yarns by supplementary weft or embroidery techniques. Large fabrics such as shoulder blankets and women's wraparound dresses were woven on the upright loom in a square or wider-than-long configuration.

Like loom-woven clothing worn in other parts of the Americas, most ancestral Pueblo clothing was untailored, worn by wrapping a piece of cloth around the body and securing it with a sash. Kiva mural paintings dating to the fifteenth through seventeenth centuries depict ancestral Pueblo men and women wearing virtually the same styles of ceremonial garments—breechcloths, kilts, shirts, shoulder blankets, wraparound dresses, belts, and sashes—that Pueblo people wear in their ceremonies today.[35] The murals thus attest to an astonishing five centuries or more of stylistic continuity in Pueblo ritual dress.

Stylistic continuity, yes. But dramatic changes have occurred in the appearance and construction of Pueblo garments during the past five hundred years. European settle-

ment in the American Southwest introduced sweeping changes to Pueblo societies that affected all aspects of Pueblo economic life, including local weaving traditions and networks of textile exchange. The establishment of missions, encroachment of Spanish settlers, and imposition of Spanish tribute requirements led to a serious decline in weaving in the Rio Grande pueblos by the mid-eighteenth century. By the late 1700s the western Pueblo villages of Acoma, Laguna, Zuni, and Hopi—not coincidentally the pueblos located farthest from Spanish population centers—were producing much of the traditional woolen clothing used by the people in other Pueblo communities. Hopi weavers were also major suppliers of ceremonial cotton textiles to the other Pueblo towns, a practice for which they are still renowned today. By this time, a new group of weavers—the Navajos—had also appeared on the scene, trading colorful ponchos and serapes to their Pueblo neighbors and to other Native and Hispanic groups.

As far as Pueblo weavers were concerned, the Europeans' major contribution was the introduction of Spanish churro sheep and their associated textile fiber, wool. Along with this fiber, the Pueblos adopted certain dyes that were associated with the weaving of wool in other regions. The most important of these was indigo, harvested and processed in the tropics and imported into the Southwest as small chunks or cakes. In addition to these new raw materials, the Pueblos adopted the European techniques of knitting and later crocheting as replacements for their prehistoric techniques of looping and interlinking and for their gauze and weft-wrap openwork fabrics. They also began making their own versions of Spanish-style, longer-than-wide blankets, or serapes, for use as floor and bed coverings and wearing blankets.

As the Pueblos selectively added new materials and techniques to their textile repertoire, other age-old practices disappeared. The early postcontact period witnessed the disappearance of most of the labor-intensive weave structures produced by the ancestral Pueblos prior to 1540. Of these, only the twill weaves and a variation of supplementary weft known as "Hopi brocade" survive into the present day. In place of their older, more complex weaves, Pueblo people increasingly turned to embroidery to decorate the borders of their ceremonial cotton fabrics and women's dresses and shawls with colorful wool yarns.

Although Pueblo people eagerly accepted European sheep, wool, new dyes, and accessory tools such as metal embroidery needles and knitting needles, they held firm to their traditional looms and spinning technologies well into the late nineteenth century. These technologies survived even later at the Hopi villages, where a few weavers still use the upright Pueblo loom developed by their ancestors. In the late 1800s, new commercial fabrics and yarns became widely available to the Pueblos and began to replace their traditional handwoven and handspun materials. Around the same time, commercially processed cotton fiber from the southeastern United States became available at the Hopi Mesas, providing Hopi weavers and spinners with new sources of fiber for their handspinning and weaving.

With the arrival of the railroad in the 1880s and the increasing participation of Pueblo men in the Euro-American economy, Pueblo women began to play an even greater role in the production of belts and woolen blankets and the decoration of embroidered ceremonial garments. Today, women are the principal producers of ritual textiles in most of the Pueblo towns, where they make extensive use of such labor-saving materials as commercial cotton monk's cloth and prespun wool and acrylic yarns for their woven and embroidered articles, and employ new decorative techniques such as appliqué. Only at the Hopi villages have men continued to be the primary producers of ceremonial textiles on traditional upright looms, and this, too, is changing with the generations.[36]

Despite largely unsuccessful attempts in the early 1900s to commercialize Pueblo weaving for a Euro-American audience, postcontact Pueblo textiles have always been, and still are, produced primarily for other Pueblo consumers. Since Pueblo people adopted Euro-American dress, Pueblo weaving has been geared almost exclusively toward the production of textiles for ceremonial use and the fulfillment of certain ritual obligations, such as gift giving for weddings and initiations. These articles are intended for consumers who already possess an innate cultural understanding of the meaning of the designs and who know the expected forms these articles should take, the ways they should be decorated, and their appropriate ritual use. These textiles are intended not to express the individual creativity of the weaver but to reify the cultural past and promote social and religious cohesion through the display of shared visual symbols.

Because the manufacture of these ritual fabrics leaves little room for experimentation, Pueblo weaving, in postcontact times at least, has been a relatively conservative artistic tradition. This probably was not the case prior to European contact, when different groups of Southwesterners expressed their social identities through distinctive regional styles of dress and when far greater stylistic diversity prevailed. As will be seen, the cultural factors underlying Pueblo textile production differ considerably from those that have influenced the direction of Navajo weaving, which from its very inception was geared toward an external and culturally diverse audience, rather than toward an internal consumer market.

PUEBLO TEXTILE STYLES IN THE CLAFLIN COLLECTION

CEREMONIAL KILTS

Kilts are wraparound, skirtlike garments that Pueblo men wear for a variety of ritual performances, including dances in which they impersonate supernatural beings known as katsinas. Archaeological evidence suggests that the ritual use of kilts dates back at least seven hundred years in the Southwest. Since the 1800s, and probably earlier, Pueblo people have decorated their kilts by two major techniques: embroidery and painting.

The Claflin collection contains two Hopi cotton kilts, both made from commercial cotton cloth, one embroidered and the other painted. Bill Claflin purchased these kilts at the Hopi Mesas in 1912 after attending the Snake Dance at Mishongnovi. The embroidered kilt (985-27-10/58872, not illustrated) was probably made between 1880 and 1910 and is constructed from commercial cotton sacking, which is readily identifiable by the woven-in purple stripes along the long dimension of the kilt. The Pueblos first acquired cotton sacking in the form of grain sacks in the late 1800s, and their use of it as a ground fabric for embroidered ceremonial textiles paved the way for the use of commercial yardage such as monk's cloth in later times. The embroidery yarns used to decorate the kilt are four-ply commercial yarns worked in the historic Pueblo embroidery stitch,[37] and the motifs represent clouds and falling rain. The painted Snake Dance kilt (985-27-10/59221, not illustrated) is made of cotton canvas and is decorated with a conventionalized design depicting an undulating serpent with body markings of bird tracks.

Procession of three Zuni Shalako
(giant birds who serve as messen-
gers of the gods) and their atten-
dants. Each Shalako wears a kilt
around the neck and two embroi-
dered white cotton mantas around
the body. The attendants wear their
embroidered mantas folded over as
kilts. The Zuni Shalako ceremony
takes place in late fall. Painting by
Hopi artist Fred Kabotie, circa
1928–1932. Courtesy School of
American Research, catalogue
number IAF.P94.

CEREMONIAL MANTAS

The manta is another ancient style of Pueblo garment. In historic times, embroidered,
plain-weave, white cotton mantas have played an exclusively ceremonial role in
Pueblo societies. These garments are traditionally made from one of the two white
cotton mantas a Pueblo woman receives from her future in-laws as part of her wed-
ding trousseau. When used in katsina dances and other ceremonies, these mantas are
usually worn over the shoulders as a shawl, often by men impersonating female katsi-
nas. Women also wear them as wraparound dresses in some ceremonies. At Zuni, two
such mantas are worn by each of the imposing supernatural beings known as Shalako .

Pueblo embroidered cotton mantas are decorated with prescribed and standard-
ized designs (see detail, pl. 1) that have their antecedents in ancient textiles and pot-
tery dating back five hundred years or more. These designs visually express the
Puebloan religious emphasis on water, rain, fertility, and cultural revitalization. The
undulating design along the inner edge of the upper border represents water or waves,

and the stacked diamonds of the lower border represent clouds. The geometric background designs, which also represent water imagery, are worked in negative patterning like that found in prehistoric pottery. The layout and designs are highly conventionalized, and usually the only choice left to the embroiderer is the selection of motifs for the diamond-shaped medallions, which typically include stylized clouds, sunflowers, dragonflies, butterflies, and birds.

The white cotton plain-weave manta with wool yarn embroidery in the Claflin collection (pl. 1) is a magnificent example of this style of weaving. It is woven of handspun native cotton, or possibly cotton batting, and embroidered with three- and four-ply commercial wool yarns. William Claflin discovered this manta in a novelty shop in Boston and believed it to be of Zuni manufacture, perhaps on the basis of the medallion designs. Unfortunately, there is no information about its history. The presence of both three- and four-ply commercial yarns suggests that the manta was embroidered sometime in the early 1870s, around the time Eastern woolen mills stopped producing the three-ply variety. Of course the cotton fabric itself could date earlier.

WOMEN'S MANTAS

Since before the time of European contact, Pueblo women have worn square or wider-than-long mantas as shawls or as wraparound dresses tied with a sash. Historic examples of Pueblo women's mantas exhibit a standardized layout consisting of a wide, undecorated center panel flanked above and below by a narrow border decorated with horizontal stripes, twill weaves, or embroidery. Four main styles of women's mantas are commonly found in historic collections of Pueblo textiles: (1) a black wool manta with blue diamond-twill borders; (2) a white wool or cotton manta with an inner red border and outer blue border, worked in diagonal and diamond twill, respectively; (3) a black wool manta with blue embroidered borders; and (4) a black wool manta with red (and sometimes also yellow or green) embroidered borders. Examples of all except the last style are present in the Claflin collection.

The most ubiquitous woman's manta style was the black and brown wool diagonal-twill manta with blue diamond-twill borders. Since at least the 1700s and until a century ago, this garment served as women's everyday wear throughout the Pueblo world. The weft yarns in these mantas were commonly darkened with a native black dye made

by cooking sunflower seeds or sumac with pine pitch and ochre; the weft yarns in the diamond twill borders were colored with indigo blue.[38] Replaced as an everyday garment during the past century by Western styles of dress, this manta still retains an important ceremonial role in contemporary Pueblo societies. So far as I know, the traditional versions with diamond twill borders are no longer being made, at least not in any quantity. However, a few solid black plain-weave mantas are being woven on European treadle looms in the Rio Grande Pueblo villages. Most new ones are fabricated from store-bought, commercial cloth.

The Claflin collection contains one example of the black wool manta style (985-27-10/58873, not illustrated). Probably woven between 1890 and 1920, it was collected by Peabody Museum

Two young Hopi women, Masha-Honka-Shi and an unidentified friend, at the Third Mesa Hopi village of Oraibi, 1898. Both wear woolen manta dresses with diamond twill borders, along with commercial cloth shawls. A Hopi banded blanket hangs at the left, and a twined rabbit-fur blanket lies at their feet. Their hair whorls reflect their unmarried status. Courtesy Denver Public Library, Western History Collection, call number X-30790. Ben Wittick, photographer.

archaeologist Samuel J. Guernsey in 1923. Considering that Guernsey was working in the Kayenta region that summer, not far from Hopi, it seems likely that he collected the manta at Hopi and that it is Hopi made. It is woven with a 2/2 diagonal twill center and diamond twill borders. The wool yarns are handspun and appear to be dyed with native black and indigo dyes, although the dyes have not been tested. As was the fashion at the Hopi villages and many other Pueblo towns, this manta dress is seamed at the shoulders and partway up one side with red commercial yarn, and the borders are outlined with commercial yarn in red and green.

A second type of woman's manta represented in the Claflin collection is the white manta with red and blue twill borders. The white center of these mantas is usually woven in a 2/2 diagonal twill, but plain-weave and other diagonal twill structures are also reported. In early examples of this style, the wide white band is wool, but cotton had become the fiber of choice for these garments by the 1870s as new sources of commercial cotton fiber in the form of batting and string became available to Pueblo weavers. The borders of these mantas are typically worked in wool, the red inner borders in a 2/1 or 3/1 diagonal twill and the blue outer borders in diamond twill. Frequently referred to by non-Pueblos as the "maiden shawl," this style of manta is a direct descendant of the prehistoric striped twill blanket so popular on the Colorado Plateau in the twelfth and thirteenth centuries.[39]

Although Hopi and other Pueblo women used this style as a fancy shawl (see p. 42), by the nineteenth century it had also acquired an important role in Pueblo ceremonies. It has historically been worn by Hopi women in the basket dance and by Hopi and Zuni men portraying female beings in katsina ceremonies. It is also an important ritual garment among the Rio Grande Pueblos, who wear it both as a shoulder blanket and folded over as a kilt. To my knowledge, the twill-woven versions are no longer made. However, plain-weave versions are woven today on European-style treadle looms in some of the Rio Grande Pueblo villages and traded to the other pueblos, including the Hopi towns.

The Claflin example of this style (985-27-10/58911, not illustrated) is woven with a commercial cotton string warp and handspun cotton weft, the latter probably spun from commercial cotton batting. The cotton center is woven in 2/2 diagonal twill,

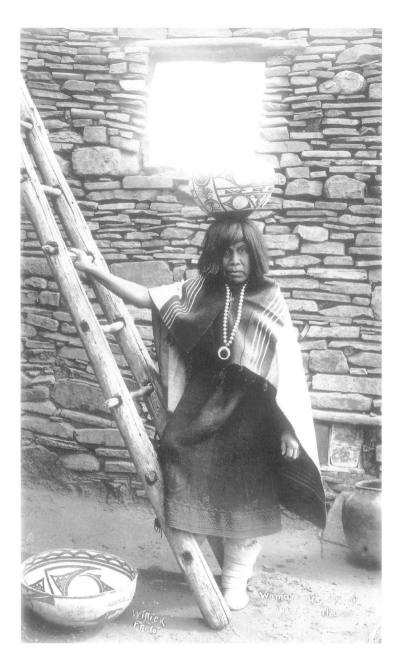

and the inner red border is worked in a 2/1 or 3/1 twill using paired strands of raveled yarns or possibly two plies untwisted from a commercial wool yarn. The outer blue border is woven in a diamond twill weave using handspun, indigo(?)-dyed wool yarn. Judging from the red yarns, the manta may date as early as 1875–1885. Unfortunately, Bill Claflin did not enter this textile in his catalogue, so its history is unknown.

A third style of woman's manta in the Claflin collection is the black wool diagonal twill manta with blue embroidered borders (pl. 2). Worn as dresses or sometimes shawls, mantas of this particular style and color combination seem to have been unique to Zuni and served as strong identifiers of Zuni female cultural identity. The style fell out of use in the late nineteenth century.

Traditionally, this manta was woven in 2/2 diagonal twill, except for the borders, which were woven in plain weave to facili–

Unidentified Zuni woman, circa 1890. She wears a dark wool manta with blue embroidered borders as a dress, and a white manta with red and blue borders as a shawl. Courtesy Denver Public Library, Western History Collection, call number x-30917. Ben Wittick, photographer.

tate the application of the embroidery. In nineteenth-century examples, the black yarns of the background fabric are dyed with what is reportedly a native dye of sumac, piñon pitch, and yellow ochre, and the embroidery yarns are indigo blue. The borders of these mantas are embroidered with geometric, negative-line designs, the most common of which is a stylized swallowtail butterfly. Less often, a diamond-framed hourglass is used. Asymmetrical floral motifs of Spanish origin typically extend along the edge of the geometric border and up the sides. According to Kate Peck Kent, five distinct types of embroidery stitches were used to decorate the different portions of the design.[40]

The Claflin collection contains a fine example of a Zuni black wool manta with blue embroidered borders, shown in plate 2. Bill Claflin purchased the manta in 1930 from Zuni trader C. G. Wallace, who considered it a "fairly old dress" at the time. The manta has a 2/2 diagonal twill center and plain-weave borders. All yarns are hand-spun, and the blue yarns have the appearance of indigo blue. The embroidery designs used to decorate the borders depict the swallowtail butterfly, and an asymmetrical floral motif extends along the outer edge of the border and up the sides (pl. 2, detail). The dress is stitched at the shoulders and up the sides with red, four-ply commercial yarns. Although four-ply commercial yarns did not appear in any quantity in the Southwest until the early 1870s, the dress itself could have been woven earlier; 1865–1880 seems a reasonable date for this piece.

MAN'S PLAID SHOULDER BLANKET OR MANTA

Plaid blankets are of great antiquity in the Southwest; archaeological examples of cotton ones date back over five hundred years. In historic times the style seems to have survived only at Hopi. Fragments of plaid wool blankets from Walpi Pueblo made between 1700 and 1850 are woven in both plain and twill weaves, whereas late nine-teenth- and early twentieth-century examples of the larger men's blankets are usually woven entirely in twill, often in elaborate combinations of diagonal, herringbone, and diamond twill. Those made for children are smaller and simpler, woven in plain weave or diagonal twill. By the end of the nineteenth century, Hopi men were no longer wearing plaid wool blankets. During the first half of the twentieth century, however,

some of the larger twill blankets were produced as revival weavings for sale to outsiders, largely in response to encouragement from the Museum of Northern Arizona. The smaller plain-weave versions are still made today for Hopi boys and occasionally for sale to non-Hopis.

The black-and-white plaid wool blanket in the Claflin collection (pl. 3) has a 2/2 diagonal twill center and borders of diamond twill. The warp and weft are of hand-spun wool, the white natural, the black colored with synthetic or native dye. The blanket was made at the Third Mesa Hopi village of Hotevilla by a weaver with the surname of Sequoptewa and won first prize at the 1937 Hopi Craftsman Exhibition at the Museum of Northern Arizona in Flagstaff (pl. 3, inset). This pristine blanket is the most recently manufactured of Bill Claflin's Pueblo textiles and probably one of the last Southwestern textiles he acquired. He likely bought it during the 1937 or 1938 Awatovi field season, either at the Hopi Craftsman Exhibition or afterward at the Hopi Mesas. Since the original show tag says "Not for Sale," Claflin may have purchased it directly from Mr. Sequoptewa.

BANDED BLANKET

Pueblo weavers began producing their own versions of Spanish longer-than-wide woolen blankets with horizontally banded, zoned layouts sometime during the seventeenth century. Although several of the banded blankets in the Claflin collection could have been made by Pueblo weavers, only one is positively attributed to a Pueblo source. The others are more likely Navajo made and are discussed in the following section.

In 1933 Bill Claflin bought a well-used Zuni wool blanket from Zuni trader C. G. Wallace. This handspun blanket (985-27-10/58899, not illustrated) was probably made between 1890 and 1910 and has a layout of five zones of narrow brown stripes on a white background. It contains several examples of an unusual type of "lazy line" in which a strand of weft yarn runs diagonally along the join, instead of perpendicular to the warp as in most lazy lines. I have seen this distinctive type of lazy line in other late nineteenth-century Zuni blankets and believe it could be a Zuni trait.[41]

Navajo weaving is much more familiar to the general public than is Pueblo weaving. Many excellent books have been written about the subject (see "Suggested Reading"). Navajo oral traditions recount how Spider Woman and Spider Man gave the gift of weaving to the Diné, or Navajo people. Most anthropologists believe that the Navajos, whom they regard as Athapaskan migrants from western Canada, adopted weaving and other traditions from the Pueblos sometime during the 1600s, perhaps when Pueblo people took refuge among, or intermarried with, groups of Navajos to escape Spanish persecution. Navajo weavers use virtually the same loom technology as the Pueblos (although not always the same weaving techniques) and produced many of the same styles of early garments as did their Pueblo neighbors.

For centuries the textile trade has played a prominent role in the commerce of Native America. Prior to Spanish settlement in New Mexico in 1598, a thriving trade existed between the settled, agricultural Pueblo communities and the surrounding nomadic tribes, with the Pueblos trading cotton textiles and agricultural foodstuffs for wild game and hides. As weaving declined among the Rio Grande Pueblos as a result of Spanish colonization, Navajo weavers stepped into this void and were soon supplying woven goods to Native and Spanish consumers. By the early 1700s Navajo weavers were known throughout the region for the fine products of their looms.[42]

Navajo textiles reached outside consumers in a variety of ways. Navajos traded blankets directly to their neighbors the Utes, Paiutes, Comanches, and Apaches for horses, buffalo robes, and buckskin, and to the Pueblos for corn, horses, and turquoise. Some blankets changed hands during raids; others reached outlying groups through down-the-line exchange. By the early eighteenth century, Native and Spanish people alike had access to Navajo blankets at the annual Taos trade fair. By the early 1800s, if not earlier, New Mexican Hispanic traders were also serving as middlemen, trading Navajo and Hispanic blankets to Native groups west of the Mississippi, especially the Shoshones and other peoples of the northern and southern Plains.[43]

Early photographs and paintings commonly depict western Native Americans, especially high-ranking political leaders and their families, wearing brightly patterned shoulder blankets of Navajo manufacture. The high status reflected in these

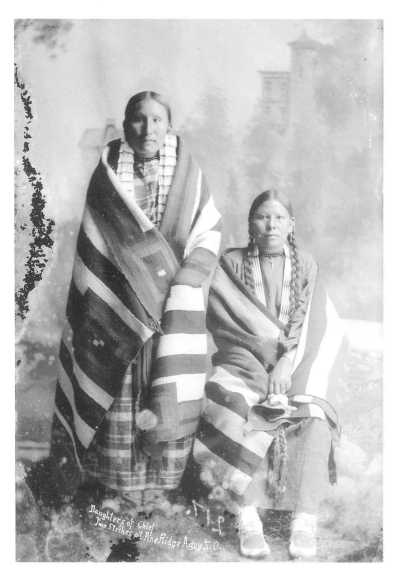

Two Lakota Sioux women, daughters of Chief Two Strikes, at Pine Ridge Agency, South Dakota, circa 1891. Both wear Navajo chief-style wearing blankets. Courtesy Denver Public Library, Western History Collection, call number X-31332. Photographer unknown.

luxury trade goods is clear. With the opening of the Santa Fe Trail in 1821 and the establishment of Fort Defiance and Fort Wingate in the 1850s, a new group of consumers, Anglo-Americans, arrived on the scene, eventually eclipsing Native Americans as the primary collectors of Navajo weavings.

Textile scholars describe the history of Navajo weaving in terms of a series of developmental phases: the Classic period (1650–1865), the Late Classic period (1865–1880), the Transition period (1880–1895), and the Rug period (after 1895).[44] In the following sections I discuss the major developments and textile styles for each of these periods and highlight examples from the Claflin collection.

THE CLASSIC (TO 1865) AND LATE CLASSIC (1865–1880) PERIODS

Navajo weaving during the Classic period was characterized by the manufacture of finely woven shoulder blankets, women's dresses, and geometrically patterned serapes. Most Classic-period weavings employ zoned layouts or bands and are decorated with simple stripes and tapestry-woven, terraced (right-angled or stair-stepped) motifs adapted from the

Navajos' coiled basketry designs. Weaving materials include handspun yarns from Navajo sheep, threads from raveled trade cloth (*bayeta*), and limited quantities of imported three-ply machine-spun yarns. The last included, by 1840, lustrous, natural-dyed European yarns known as Saxony and, by the early 1860s, synthetic-dyed yarns from Germantown, Pennsylvania.

Classic-period textiles normally exhibit a restricted color palette of red, blue, white, brown, and black. The red is derived from lac, cochineal, or, after 1860, synthetic dyes, the blue is from indigo, and the others come from natural shades of wool. Vegetal yellows and greens are also used as accessory colors. Navajo weavers lacked a good local dye source for red, so they obtained their reds from pre-dyed, machine-spun wool yarns or, more commonly, by unraveling threads from wool trade cloth, known as bayeta. The Navajos seem not to have made much use of the Mexican import dye cochineal for their handspun yarns, although at least one example has been reported.[45]

The Classic period was brought to an end by the incarceration of the Diné at Bosque Redondo, or Fort Sumner, New Mexico, between 1863 and 1868. A major defining event of Navajo culture and history, this period of imprisonment followed the devastating campaign by Kit Carson and the United States Army against the Navajo people and the "Long Walk" of the Navajos to southeastern New Mexico. These hardships caused tremendous loss of Navajo life and the complete disruption of the Navajo economy. One of the many facets of life affected by these events was the production of Navajo textiles.

The period between about 1865 and 1880 is known as the Late Classic period. It seems astonishing that Navajo weavers were able to create objects of such beauty in the devastating wake of Bosque Redondo, yet some of the loveliest of all Navajo weavings were made during this time. Late Classic weavings reflect the decreased availability of Navajo wool supplies following the decimation of flocks during the Bosque Redondo years, together with Navajo weavers' increased access to new sources of imported, pre-dyed wool trade cloth and machine-spun yarns. Navajo weavers were issued synthetic-dyed three-ply Germantown yarns at Bosque Redondo, along with some commercial cotton string. After their return to the reservation in 1868 and until

the end of the government annuity program a decade later, the Navajos received vast quantities of commercial wool yarns through the Indian agency at Fort Defiance and nearby military posts. At first these were three-ply yarns from Germantown, Pennsylvania, but by the early to mid-1870s these had been largely replaced by four-ply yarns manufactured in Germantown and at other Eastern mills.[46]

Some Late Classic textiles contain an amazing mix of handspun and commercial materials, whereas others are made entirely of machine-spun yarns and contain no handspun wool whatsoever. It is not uncommon to find a Late Classic weaving that incorporates white and indigo-dyed handspun, a range of commercial yarns, several different shades of red raveled threads, and raveled, recarded, and respun yarns (see, for example, pl. 8). Popular design motifs during the Late Classic period include serrated (sawtooth) diamonds, triangles, and other design elements derived from Mexican Saltillo serapes, as well as a distinctive type of cross motif with small squares at the corners, often referred to as a "Spider Woman cross." These elements appear either in zoned banded layouts or, in a radical departure from earlier styles, as bold, overall designs.

The Late Classic period also saw the increased manufacture of small, finely woven and decorated serapes, sometimes referred to as "child's blankets." There is little indication from the historic photographic record that such blankets were ever produced for Navajo children. Rather, they seem to have been intended for use by Navajo, Ute, and other Native consumers as saddle blankets and perhaps women's shawls and by Euro-American government officials as souvenirs. Reducing the size of their weavings was one way for Navajo weavers to streamline the production process and maximize the use of limited quantities of raw materials. The prevalence of these small weavings during the 1870s speaks to their importance in the post–Bosque Redondo Navajo trade economy.

Euro-Americans became increasingly significant consumers of Navajo weavings during the late nineteenth century. As the Claflin collection well illustrates, high-ranking military officers, Indian agents, and other government employees were frequent collectors of these goods. It was common practice for army officers and even enlisted men to decorate their quarters (and later their homes) with Navajo blankets

and other Native curios. Although some Navajo blankets are known to have found their way into military collections as spoils of war, others seem to have been made expressly for this army trade, perhaps commissioned directly from Navajo weavers by officers stationed nearby.

The establishment of Fort Defiance and Fort Wingate in Navajo country in the 1850s gave Navajo weavers easy access to this new group of consumers. Not only were these places where Navajos and Euro-Americans had frequent contact, but between 1868 and 1878 they were also the places where commercial yarns and trade cloth were distributed to the Navajos. By the late nineteenth century, both of these areas had become important centers of Navajo weaving, Fort Defiance (near present-day Window Rock) in the western part of the reservation, and Fort Wingate (in its third and present location, near modern-day Grants) in the east.[47]

CLASSIC AND LATE CLASSIC STYLES IN THE CLAFLIN COLLECTION
Women's Two-Piece Dresses. The Navajo woman's two-piece dress (*biil* in the Navajo language) was, and still is, an important emblem of Navajo female cultural identity. Because these garments were made for internal Navajo use, not for trade, they exhibit the same degree of conservatism and standardization in design as many traditional Pueblo textiles. At one time the two-piece dress was the main article of daily wear for virtually all Navajo women (see pp. 12 and 20). Some young Navajo women still wear this dress during the *kinaaldá,* or puberty ceremony, and on a few other social occasions. However, Navajo women today more commonly wear the velveteen blouse and broomstick skirt as a traditional style of dress. This Navajo adaptation of a European clothing style replaced the two-piece dress for daily wear after the Navajo people returned from Bosque Redondo.

The Navajo two-piece dress shares a close historical relationship with the Pueblo manta. When the two panels of the dress are arranged side by side, as shown in plate 4, and mentally joined, the result is a wider-than-long manta with a solid, wide center panel and two decorated borders. The earliest Navajo dresses were one-piece mantas like those worn by the Pueblos. Sometime in the 1700s the Navajos modified this manta dress by dividing it into two longer-than-wide panels, which they decorated

with woven-in tapestry designs. They wore this dress by seaming the panels together at the shoulders and partway up the sides, leaving the seams open at the lower edge.

I have wondered whether the original inspiration for the Navajo two-piece dress (as well as the "fancy manta," which I discuss later) might not have been the Pueblo black wool manta with red embroidered borders that was so popular at San Juan, Tesuque, and Acoma Pueblos. Navajo weavers might have substituted their own geometric tapestry motifs for the Pueblo embroidered designs. Ann Lane Hedlund speculates that the Navajo two-piece dress might have been an outgrowth of the northern hide clothing tradition of using two pieces of hide for the front and back parts of a dress. I would add that this modification probably had something to do with the horse and livestock economy of the Navajos, given that the two-piece dress offers greater freedom of movement for the legs than the more confining Pueblo wraparound manta dress.[48]

The Claflin collection contains six of these dresses, all wonderful examples, two of which are illustrated in plate 4. Probably the earliest example is the dress patterned with simple stripes that is shown in the inset of plate 4, said to have been collected by New Mexico military governor Sterling Price sometime between 1846 and 1848. If not the oldest of Claflin's textiles, it is certainly the earliest documented piece in his Southwestern textile collection.

The second, third, and fourth of the six dresses, including the other one shown in plate 4, appear to date to the period 1850–1870. The third dress (985-27-10/58902, not illustrated) comes from the Eliza Hosmer collection, and the fourth (985-27-10/58895, not illustrated) was purchased by Bill Claflin from a curio dealer in Boston. The fifth dress in the collection (985-27-10/58914, not illustrated) was found in a saddle shop in Telluride, Colorado, by a Mrs. John Lowe and is decorated with Spider Woman crosses. It probably dates to the 1870s, when the use of these cross motifs was especially popular. The sixth and most recent example (985-27-10/58883, not illustrated), made from late raveled flannel and probably woven between 1875 and 1890, was discovered by Bill Claflin in a Boston pawnshop.

Chief-Style Blankets and Rugs. The Claflin collection features an outstanding group of chief-style wearing blankets. The name "chief blanket" derives from the fact that

many of these prized textiles were acquired through trade by non-Navajo leaders from the Plateau, Plains, and Great Lakes tribes. Like the traditional Pueblo manta from which they are historically derived, these mantalike shoulder blankets were woven in a wider-than-long configuration and were wrapped around the body with the design bands parallel to the ground. The Claflin collection contains eight chief-style blankets representing all of the major design phases, six of which are illustrated in plates 5–10. The collection also contains a twentieth-century floor rug decorated with a chief-style design.

Chief-style blankets are described in terms of four temporal and stylistic periods, or phases. The first-phase chief blanket is the earliest and simplest style, dating from at least as early as the late eighteenth century and produced until around 1860. It is sometimes referred to as the "Ute style" because of its popularity among the Utes, although people of other tribes also used these blankets.[49] The first-phase layout consists of five horizontal zones: a wide, dark-colored zone of narrow indigo blue and dark brown bands or stripes at the center and each end, separated by groups of alternating white and brown-black bands. In some first-phase blankets the blue bands are framed in red. The Claflin collection contains one excellent example of a first-phase chief blanket (pl. 5), acquired as part of the William Morris collection.

In the second-phase style (circa early 1800s to 1870), the blue bands are elaborated with red rectangles or bars to produce twelve spots of color. The Claflin collection contains two examples of this style, one a superb piece collected by William Stanley Hatch in the 1860s (pl. 6) and the other from the Morris collection (985-27-10/58886, not illustrated); the latter still retains some of its original wool nap. The collection also contains two blankets with modified second-phase layouts in which the center and end zones are decorated with more elaborate designs. The one shown in plate 7, from the Hosmer collection, is patterned with alternating T-shaped elements, whereas the blanket in plate 8, another Morris piece, is decorated with meanders. Both contain the characteristic mix of handspun, commercial, and raveled bayeta materials so typical of the Late Classic period, and they probably date to the 1870s.

Third-phase blankets (circa 1860 to 1880) have a nine-spot layout, usually consisting of a diamond at the center and half- and quarter-diamonds at the ends and

corners. Bill Claflin originally owned four such blankets, two of which are now in the Peabody Museum collections. The other two were given away prior to his bequest.[50] The blanket shown in plate 9, collected by Eliza Hosmer, is a lovely example dating to the 1860s. The other (985-27-10/58876, not illustrated) dates to the 1870s and was purchased by Bill Claflin in 1923 from the Fred Harvey Indian Store in Albuquerque.

In the fourth-phase style (circa 1870 to 1885), the third-phase design is further elaborated by merging the diamonds along the vertical axis. The Claflin example (pl. 10) takes this design to a particularly high level of abstraction. The collection also contains a more sedate version of the fourth-phase style, this one a floor rug dating to the 1930s (985-27-10/58920, not illustrated).

Women's Wearing Blankets and Mantas. The collection contains examples of two different Navajo women's manta styles, one a striped plain-weave shoulder blanket and the other a twill-woven shawl, both decorated with tapestry designs. Women's striped shoulder blankets are essentially smaller versions of the men's chief-blanket styles but differ from the latter in usually having narrow gray and black or white and black bands in place of the wide black and white ones. Like Navajo men's chief blankets, women's wearing blankets were historically derived from the Pueblo wraparound manta. Most examples of Navajo women's shoulder blankets date to the 1870s or early 1880s and incorporate crosses, zigzags, or meander designs into the second- or third-phase layout. Like chief blankets, many of them were traded to other Native groups, especially the Utes.

The woman's blanket in the Claflin collection that is shown in plate 11 and on the cover of this catalogue is a marvelous piece with a simple yet striking design and remarkable depth of color. Charles Avery Amsden offered a rather different interpretation of this weaving, using it to illustrate what he saw as the "decadence of the shoulder blanket."[51] The blanket was collected by Frank Clark on the Shoshone Reservation in Utah in the 1870s. Judging from the composition of the yarns, which include a small amount of aniline-dyed handspun, the blanket was probably made around 1875.

The other style of woman's wearing blanket in the collection is a type of shawl with a solid-colored center and decorated twill borders, sometimes referred to as a fancy manta.[52] These blankets, too, bear a strong resemblance to Pueblo women's mantas, but they differ from the latter in having twill tapestry designs woven into the borders. They seem to be a Navajo reinterpretation of the Pueblo embroidered manta or twill-banded maiden shawl. Although this style of manta was worn by Navajo people, some examples were collected at Zuni and are shown in early photographs being worn by Zuni women. This implies that they were traded by the Navajos to the Zunis or that Zuni weavers wove them as well.

The example in the Claflin collection (pl. 11, inset) came from the William Morris collection but is otherwise undocumented. The center is woven in a diagonal twill, the decorated borders in twill tapestry, and the blue borders in diamond twill. As I have noted, Morris's collection contained textiles collected by both Morris himself and General George Crook. This blanket seems to me a good contender for being one of Crook's pieces, because the style is not typical of Navajo shoulder blankets traded to the Plains tribes. Claflin thought the manta could have been made at Hopi or one of the Rio Grande Pueblos, but I concur with Joe Ben Wheat's assessment that it is probably of Navajo or possibly of Zuni manufacture.[53]

Unidentified Navajo man, photographed with Late Classic Navajo serapes, 1879. The light-colored blanket on his lap is likely of Hopi manufacture. The photograph was probably taken at the First Mesa Hopi village of Walpi. Peabody Museum, Harvard University, photo N35489. John K. Hillers, photographer.

Serapes and Saddle Blankets with Tapestry Designs. Unlike wider-than-long styles of wearing blankets, the longer-than-wide serape was derived from a Spanish model, not a Pueblo one. Sometime during the 1600s, Navajo people saw Pueblo versions of these woolen, weft-faced, banded blankets made on upright looms, and probably also

Mexican- or New Mexican–made blankets made on European treadle looms. By the early 1700s the Navajos were weaving this style as well, decorating their blankets with tapestry-woven terraced motifs taken from Navajo basketry. The result was the finely woven Navajo serape that was coveted by Hispanic, Pueblo, Plains, and other western consumers for its waterproof qualities, eye-catching colors, and distinctive geometric patterning.

One of the major strengths of the Claflin collection is its exceptional assemblage of fifteen Classic and Late Classic serapes. The stunning Classic-period serape shown in plate 12 is believed to be the earliest serape in the Claflin collection, probably woven prior to the Navajos' incarceration at Bosque Redondo. Containing handspun, raveled, and lustrous Saxony(?) three-ply commercial yarn, it was likely made between 1850 and 1865. Unfortunately, this was one of several serapes stolen from Bill Claflin's private museum in the 1970s. Although, thankfully, it was recovered, its original Claflin number was lost, and this particular textile is not included in the Peabody's copy of the Claflin catalogue. Thus its original collection history is unknown.[54]

Other serapes in the Claflin collection were woven during the Bosque Redondo period or following the Navajos' return to their former land. Plates 13 and 14 illustrate two examples in the collection that probably date to the 1860s. Both were collected by Indian agent Henry F. Boyd on the Southern Ute Indian reservation in the 1870s. The one shown in plate 13, which Bill Claflin referred to as "the gem of my collection," has documentation linking it to the respected Ute leader Chief Ouray (see p. 15 and the biographical section on Henry Bond). That shown in plate 14 is another beautiful piece, simply yet effectively patterned with alternating T-shape motifs.

The two blankets shown in plates 15 and 16 were collected by Captain Charles A. Hartwell while stationed at Fort Wingate, or perhaps Fort Defiance, sometime between 1869 and 1873. Although the designs of these blankets differ, both contain many of the same shades of three-ply commercial yarns, now discolored by fading. It seems likely that the weaver or weavers who made these two pieces had access to virtually the same supplies of commercial yarns, probably issued at Fort Wingate or through the Navajo agency at Fort Defiance. Differences in the direction of the warp yarns (one has a final S-twist, the other a final Z-twist) and selvage treatments (one

has a self-fringe, the other does not) suggest that different weavers could have been responsible for making these pieces, but this is by no means certain. Although Claflin's documentation from Hartwell's son states that these blankets were given to Hartwell by Indian chiefs, it is intriguing to speculate that Hartwell might have purchased or even commissioned the pieces from Navajo weavers he came to know while stationed at Fort Wingate. Many Late Classic blankets were collected by high-ranking military personnel and may have been made expressly for this army officer trade.

Plate 18 illustrates a particularly lovely example of a Late Classic serape with an extraordinary blue palette and a design reminiscent of canyon and sky. Judging from the presence of four-ply commercial yarns in the side cords and tassels, the serape probably dates to the early 1870s. This piece, together with five other Late Classic serapes in the collection, is among the wonderful group of weavings collected by Eliza Hosmer.[55] The one in plate 19, a saddle blanket, contains a distinctive "carded pink" yarn, made by carding together white wool fiber and bits of red bayeta threads, whereas the blanket in plate 20 is made with fuzzy red threads unraveled from flannel trade cloth. Both probably date to the 1870s.

The small, finely woven serape or saddle blanket shown in the inset of plate 19 was reportedly collected by W. F. M. Arny at old Fort Wingate sometime around 1874. It contains handspun, raveled, and three-ply commercial yarn, the last probably an early Germantown yarn. Several other Late Classic serapes in the collection, not illustrated, exhibit the characteristic mix of handspun, raveled, and three-ply and four-ply commercial yarns so characteristic of the post–Bosque Redondo period. Other Late Classic serapes from the Claflin collection not illustrated or mentioned elsewhere in this catalogue are 985-27-10/58875, 58900, 58905, 58910, 58928, and 58929.

Moqui-Pattern Blankets and Rugs. Moqui-pattern blankets are a distinctive style of weft-faced serape decorated with bands of alternating blue and dark brown stripes. The name "Moqui" comes from an archaic Spanish term for the Hopi people, but in this case it is a misnomer, because there is little indication that Hopi weavers ever produced this style of blanket, preferring instead those with white or light-colored backgrounds (see pp. 40 and 53). The so-called Moqui style of blanket was, however,

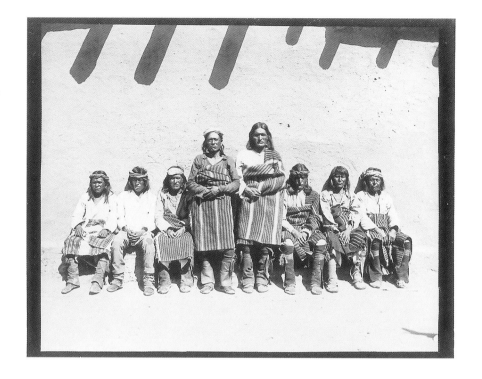

Group of Zuni leaders at Zuni Pueblo, 1879. The six men at right wear Moqui-striped blankets. The light-colored blanket at left may be of Hopi manufacture. Courtesy Denver Public Library, Western History Collection, call number z-1926. John K. Hillers, photographer.

woven at several of the other pueblos, including Acoma, Isleta, and Zuni. Blankets of this design were also made by Rio Grande Hispanic and Navajo weavers. The Claflin collection contains four examples of blankets or rugs patterned with Moqui stripes, including the serapes shown in plates 17 and 22.

Distinguishing between a treadle-loom-woven Hispanic weaving and a Navajo or Pueblo textile made on an upright loom is usually a relatively simple task. Among other differences, textiles woven on treadle looms have a cut warp at both ends that is usually tied off in a fringe, whereas the vast majority of textiles woven on Southwestern upright looms have complete (uncut) warp selvages. When a Navajo or Pueblo textile does have a fringe, it is usually a self-fringe made of uncut warp loops, like that shown in plate 15, or an applied fringe added after the weaving process is complete, like those found on many Germantown saddle blankets and rugs. Certain Navajo textile

styles (for example, Gallup throws and Germantown weavings with a cotton warp) often have the warp cut and knotted into a fringe at one end, but I am unaware of any examples with a cut warp at both ends. In the Southwest, this seems to be a characteristic of treadle-loom weavings alone.

Differentiating a Navajo weaving from a Pueblo one is a far trickier proposition, since both are made using the same loom apparatus. Navajo and Pueblo weavings sometimes can be distinguished by the composition of the selvage cords (research by Joe Ben Wheat reveals that nineteenth-century Navajo weavings usually have two three-ply cords, and Pueblo ones, three two-ply cords) or by the fact that Pueblo blankets tend to be wider in relation to their length (more square in shape) than Navajo ones.[56] However, the differences are not always clear-cut, and identifications often depend on the subjective impressions of the observer.

The blanket shown in plate 17 provides a case in point. Bill Claflin identified it as Hopi, whereas Joe Ben Wheat, who examined it in the early 1970s, considered it Navajo. In my opinion it could be either Navajo or Zuni. The selvage cords (two three-ply) and type of tassel finish suggest a Navajo origin, whereas the squarish proportions and unusual design symmetry of the wide central band seem to me more indicative of Pueblo weaving. The blanket comes from the William Morris collection and lacks any documentation, but on the basis of its materials, it probably dates around 1875.

A second Moqui-stripe blanket in the collection (985-27-10/58882, not illustrated) was also identified by Bill Claflin as Hopi. I believe it to be Navajo, although an Isleta, Zuni, or Acoma attribution is possible. Judging from its cotton string warp and aniline-dyed selvage cords, the blanket probably dates to the 1870s. Claflin purchased it in 1929 from a Santa Fe dealer named Collins. In another example of the Moqui style, illustrated in plate 22, the Moqui stripes are relegated almost entirely to the background. The colors and terraced designs in the broad bands of this serape are typical of the Late Classic period, and the extensive use of red four-ply Germantown yarn suggests a post-1874 date for the piece. The serape was collected by Rowland Gibson Hazard II. Finally, the collection contains a Moqui-style floor rug (985-27-10/58931, not illustrated) dating to the period 1895–1925.

Twill-Woven Saddle Blanket. The Claflin collection also contains an unusual example of a Late Classic twill-woven saddle blanket or throw (985-27-10/58892, not illustrated). What makes this weaving so distinctive is its weft, which consists of bundles of cloth strips cut from flannel bayeta yardage. The warp is a three-ply commercial yarn, and the blanket also contains small quantities of handspun yarn. It is woven in a balanced diagonal-twill weave and has an uncut self-fringe at one end. The piece probably dates to the early 1870s and comes from the William Morris collection.

THE TRANSITION PERIOD (1880–1895)

Privately owned trading posts were established on the Navajo Reservation in the late 1870s, and the railroad reached the fringes of the reservation in 1881. Navajo weaving during the Transition period was characterized by access to new sources of imported raw materials, including packaged aniline dyes, by the growing influence of reservation traders and other Euro-Americans on the products of Navajo looms, and by a new level of innovation and experimentation on the part of Navajo weavers. During this period Navajos and other Native people turned increasingly to machine-made goods, such as Pendleton blankets, for their clothing needs. As a result of this shift, Navajo weaving was largely redirected toward the sale of floor rugs and other textiles to Euro-American consumers.

The range of materials found in Transitional weavings includes handspun wool yarns in natural shades of white, brown, and gray or, sometimes, dyed with indigo or colored with pre-packaged synthetic dyes. Weavers also used commercial cotton string for warp, new and brighter shades of synthetic-dyed, four-ply commercial wool yarns, and threads unraveled from fuzzy, synthetic-dyed, red wool flannel cloth. Like those of the Late Classic period, Transitional weavings frequently contain an eclectic mix of materials, although some are made entirely of either handspun or commercial yarns. Those with yarns primarily of machine-spun wool (sometimes with a cotton string warp) have come to be known as "Germantowns," despite the fact that a number of mills elsewhere were producing such yarns by this time.

As the audience for these weavings shifted to non-Native consumers, Navajo weavers, less bound now by social convention, experimented freely with new design

elements and color possibilities. Transition-period weavings are more inventive, dynamic, and colorful (hence the term "eye-dazzler" for some of them) than those of earlier periods; they reflect a burst of creativity on the part of Navajo weavers. Designs used in Transitional textiles range from Saltillo-inspired serrated diamonds and zigzags, interlaced trellises, and Greek meanders to letters of the alphabet and fanciful images of livestock and trains. Other innovations during this period include the application of fancy, multicolored fringes and elaborate tassels to saddle blankets and rugs and the use of a new pulled-warp technique known as wedge weave.

TRANSITION-PERIOD STYLES IN THE CLAFLIN COLLECTION
Banded Blankets and Rugs. Claflin's collection at the Peabody contains nine Transitional banded blankets, including one example of a wedge weave. Six of these blankets are made of handspun wool and fall into the category that Navajos call *diyugi,* or soft wearing blanket. Two others were made to serve as floor rugs. These Transition-period weavings make extensive use of aniline-dyed handspun and incorporate such elements as meanders, trapezoidal bands ("diamond stripes"), and serrated motifs into their design bands. One blanket (985-27-10/ 58891, not illustrated) may be of Pueblo rather than Navajo manufacture.

The small serape or saddle blanket illustrated in plate 21 is another one of Eliza Hosmer's wonderful pieces. Dating to about 1880, the blanket combines what appear to be aniline-dyed red and orange handspun yarns with plant-derived indigo blues and greens. The color palette of this blanket is reminiscent of the bright pastels found in Hispanic weavings of the same period from the Rio Grande Valley.

The Claflin collection also contains an example of a wedge-weave, or pulled-warp, blanket (pl. 23). Wedge-weave blankets are an eccentric variation of the banded diyugi in which the wefts are inserted at an angle oblique to the warp. This process forces the warp out of its normal vertical alignment, giving the blanket a telltale scalloped edge. Chevrons, diagonal stripes, and zigzags are common design elements produced by this technique. Most wedge weaves date to the 1880s, but some are a bit earlier, and the technique seems to have survived into the 1890s. The original inspiration for the technique has not been determined—it could easily have been a Navajo

innovation—nor is it known whether the technique was practiced all over the reservation or in just one region. The example from the Claflin collection contains white, indigo, and aniline-dyed handspun as well as four-ply commercial yarns, and it probably dates to the 1880s. It comes from the William Morris collection. Other Transitional textiles with banded designs in the Claflin collection not illustrated in this catalogue are 985-27-10/58881, 58898, 58916 (floor rug), 58917 (floor rug), 58923, and 58926.

"Eye-dazzler" Blankets and Rugs. The Claflin collection includes four examples of weavings patterned with all-over serrated or terraced designs worked in bold color palettes (none illustrated). The name "eye-dazzler" is commonly used to describe Transition-period weavings of this style. One of these weavings (985-27-10/58887), from the William Morris collection, is made of four-ply commercial yarns, and another (985-27-10/58909), collected by Eliza Hosmer, is of handspun yarn colored with synthetic, indigo, and probably vegetal dyes. Both are typical of the 1880s. The other two, probably dating to the 1890s, are large handspun floor rugs patterned with oversized designs. One (985-27-10/58915) is patterned with large, floating crosses, and the other (985-27-10/58924) features oversized serrated diamonds. Both are characteristic of the trader-influenced rugs made during the late Transition period.

THE RUG PERIOD (1895–1940)
Navajo weaving after 1895 was typified by the production of rugs and other specialty weavings for a Euro-American audience. This period witnessed an increase in tourism to the Southwest and a growing demand for souvenirs, the increased marketing of Navajo weavings through reservation trading posts, and the subsequent rise of distinctive rug styles associated with specific parts of the Navajo Reservation. Textiles of this period vary widely, from ones woven entirely of synthetic-dyed, commercial yarns to beautiful handspun rugs in natural wool shades or colored with synthetic or vegetal dyes. Major developments during this period included the introduction of oriental rug designs to the Navajos by traders J. B. Moore, C. N. Cotton, and J. L. Hubbell, which led to the rise of the Crystal, Ganado, and, later, Two Grey Hills styles,

and the emergence of revival movements intended to bring back some of the older Classic-period styles. The latter included Juan Lorenzo Hubbell's efforts to reproduce Classic-period blankets in his trading post at Ganado and a revival movement out of Chinle involving the use of vegetal dyes.[57]

EARLY RUG STYLES IN THE CLAFLIN COLLECTION

Hubbell Revival Weaving. Juan Lorenzo Hubbell of Hubbell Trading Post tried to forestall the passing of the older Classic-period serapes by encouraging local weavers to produce weavings in the older banded styles using traditional palettes of red, white, and blue (or, in Hubbell's case, red, white, and black). He marketed these revival weavings, some of which were direct imitations of Classic-period blankets, through his mail-order business and his trading post in Ganado, Arizona. Although these Hubbell revival weavings exhibit the designs, layouts, and color combinations of the Classic period, most are made entirely of commercial yarns and were designed to fulfill a variety of Euro-American needs. For instance, Hubbell's 1905 catalogue advertised oversized floor rugs "for dining room and parlor use" and large, curtain-like weavings, called portieres, for covering doorways.[58]

In the ultimate quest for authenticity, Hubbell commissioned a few local weavers to produce bayeta blankets using threads unraveled from modern woolen cloth. One such textile is the weaving shown in plate 24, which Bill Claflin purchased in 1923 from a Mike "Quirk," who had acquired the blanket directly from Hubbell. (Mike Quirk was almost certainly Gallup trader Mike Kirk, a prior employee of Hubbell's.)[59] Claflin's catalogue entry identifies this blanket as one of three that Hubbell commissioned in 1896 that used English bayeta he imported expressly for this purpose. Charles Amsden wrote about this blanket in his study of Navajo weaving, describing it as "the only pristine bayeta extant."[60]

Claflin learned the details of the blanket's manufacture in 1930 while visiting Herman Schweizer of the Fred Harvey Company in Albuquerque. Schweizer told Claflin that not only had he seen one of these blankets at Hubbell Trading Post while it was still on the loom, but he also had furnished Hubbell with the older textile used as the model. Schweizer still had this older weaving in his possession and showed it to

Claflin during his visit. Claflin's version of the story ends there, but research for this book led to the discovery of the blanket shown in the inset of plate 24, believed to be Schweizer's model, now in the collections of the Maxwell Museum of Anthropology in Albuquerque. All that is known about the history of this blanket is that Gilbert Maxwell acquired it from the Fred Harvey Company sometime prior to 1963. If the other two bayeta blankets made from this model exist, their whereabouts are unknown.

Claflin's Hubbell revival piece is a far cry from the soft bayeta blankets of earlier times. Rather, it is a thick, heavy thing, incorporating commercial, handspun, and fuzzy raveled yarns. The weaver seems to have lacked experience in the preparation of raveled threads, for she neglected to unravel them completely before incorporating them into the weft. As a result, the surface of the blanket is covered with hundreds of loose thread ends. Although Claflin's piece is larger than the original and of slightly different proportions, it is a striking piece with a fascinating history and is faithful to the model in most respects.

Chinle Revival Weaving. One example of what is probably a Chinle revival weaving is also found in the collection (pl. 25). At first glance, this undocumented piece resembles a Transitional banded blanket, but its proportions, design layout, colors, and quality of wool vary in important ways from those of other Transitional weavings. Rather, this blanket resembles some of the revival-style blankets promoted by traders Cozy McSparron, Camilo Garcia, and Hartley Seymour in the 1920s and 1930s at their posts near Chinle, Arizona. With the input and financial assistance of Boston-area philanthropist Mary Cabot Wheelwright, these traders (and later also Sallie and Bill Lippincott at nearby Wide Ruins Trading Post) encouraged local weavers to produce blankets combining the older Classic-period banded layouts with terraced and serrated motifs, albeit in new color palettes and combinations.

The vast majority of these Chinle revival weavings were made in soft, muted pastels resulting from the use of vegetal dyes. A few weavers, however, made use of a synthetic dye known as DuPont dye, developed expressly for the Navajo trade to improve the quality of the colors. Although these dyes produced superior coloration, their use, predominated by red, was relatively short-lived for a number of reasons. They

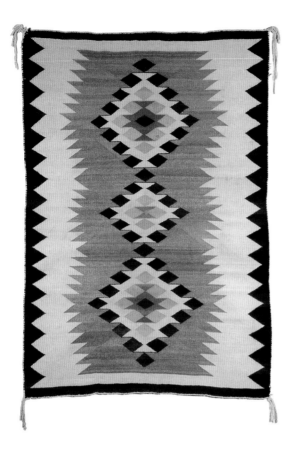

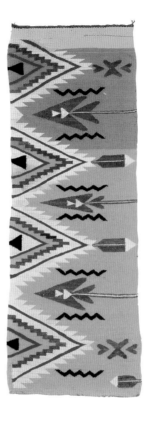

Two regional-style rugs from the Claflin collection. In addition to his museum-quality pieces, Claflin purchased contemporary Navajo weavings to decorate his home and museum. Left: Navajo Two Grey Hills–style rug, circa 1910–1940; catalogue number 985-27-10/58922; handspun wool warp and weft, natural white and aniline dyes; 114.5 × 164.5 cm. Right: Navajo Gallup throw–style runner, circa 1900–1930; catalogue number 985-27-10/58927; cotton string warp; handspun, commercial, and rag weft; natural white and aniline dyes; 43 × 95.5 cm. (Left: T3940.3; right: T3806.3. Hillel S. Burger, photographer.)

Borders at the edges of Navajo textiles began to appear only after the Navajos were confined to reservations. As they were increasingly subjected to boundaries, their worldview and design sense began to reflect these restrictions. As Navajos began wearing machine-woven blankets, their weavings evolved into rugs and decorative hangings commissioned by traders. Designs became more subdued; colors were limited to black, white, gray, and red. Proportions and designs were no longer linked to the scale of the body, and rugs now came in all sizes and shapes. —Tony Berlant

required more water to process than other packaged dyes (water is a precious resource on the Navajo Reservation), and they were more difficult to handle because the mordant and color had to be mixed separately. They were also more expensive to buy. Consequently, rugs colored with these dyes are relatively rare. Amsden illustrated a revival–style rug with a red background colored with these "better quality" aniline dyes, and the Claflin rug shown in plate 25 appears to be a similar example.[61]

Other Regional Rug Styles. The Claflin collection contains six floor rugs made between 1900 and 1940 that display regional rug designs. Five of these are made of handspun

wool. Three (985-27-10/58922; previous page, left; 985-27-10/58918 and 985-27-10/58921, not illustrated) have the black, white, tan, and gray color palette characteristic of the Two Grey Hills region of northwestern New Mexico, and two others (985-27-10/58919 and 985-27-10/60494, not illustrated), woven in shades of black, white, gray, and red, are typical of weavings made near Crystal, New Mexico. None is a particularly outstanding example of these styles.

The sixth weaving (985-27-10/58927, previous page, right) differs from the others in design and in its use of commercial materials. Small novelty weavings like these are commonly referred to as Gallup throws, and the Claflin piece is a particularly animated example. Containing a hodgepodge of materials—selvage cords and warp yarns of commercial cotton string and weft elements of synthetic-dyed handspun wool, commercial four-ply wool yarn, and cotton rag strips—this rug juxtaposes Saltillo-like serrated motifs with feathers and spear points, quintessential symbols of "Indianness." It is a perfect example of the inexpensive novelty weavings produced for the curio trade. This piece is plain good fun, and it is easy to see why Claflin chose to take it home. After all, what greater contrast could there have been to his exquisite collection of nineteenth-century wearing blankets?

CONCLUDING REMARKS

When William H. Claflin Jr. acquired his Southwestern weavings and entered them into his blanket catalogue, he had no inkling that the Peabody Museum would one day publish a book about him and his collection. From what I have learned about Claflin's personality and narrative style, I have no doubt that he could have written a far more engaging history of his own life and collecting activities and offered considerably more detailed and colorful accounts of his collectors' lives. More than half a century after he collected these weavings, we have only bits and pieces—snippets of yarn, if you will—with which to weave a story of the past. Writers have presented fictionalized accounts of weavings as they passed through the lives of their collectors,[62] but Bill Claflin did one better. He bequeathed to us real-life accounts that enable us to track the trajectories of his textiles as they moved from hand to hand, from west to east.

These are only glimpses, but what a story they tell. How many hundreds of other stories have been lost as collections were broken up and sold?

Despite the impressive history of this collection, some critical voices are missing. In only one case, that of a modern Hopi blanket, is the weaver of any of these textiles known. We know virtually nothing about the lives of the individual artists who created these textiles or of the Hopi, Zuni, Navajo, Ute, and Plains people who acquired, wore, and cherished them. Nor do we know anything about the circumstances regarding their exchange from Native hands to Euro-American ones. Much is known about the history of the Claflin collection, but without these other voices, the story can never be complete.

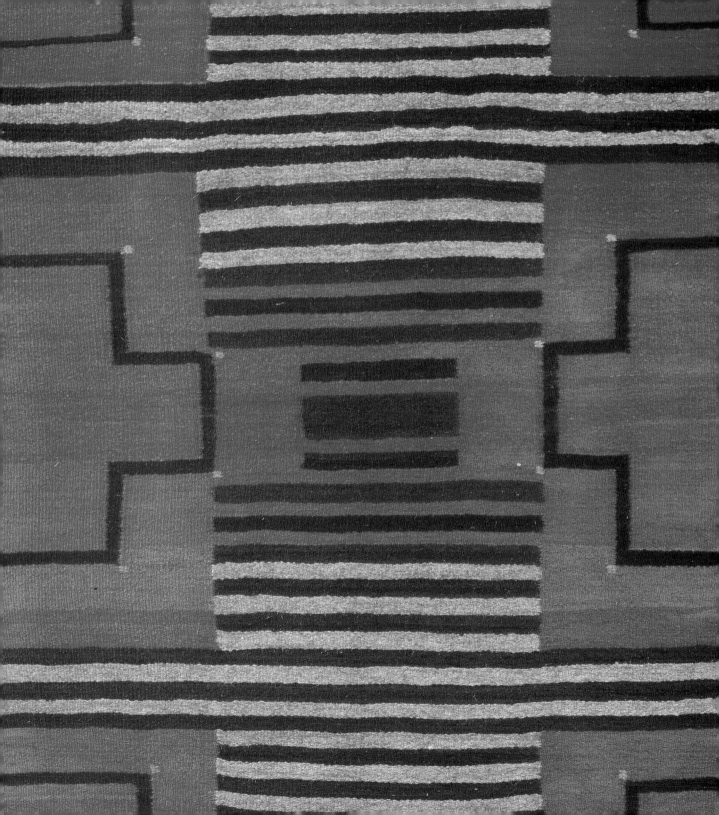

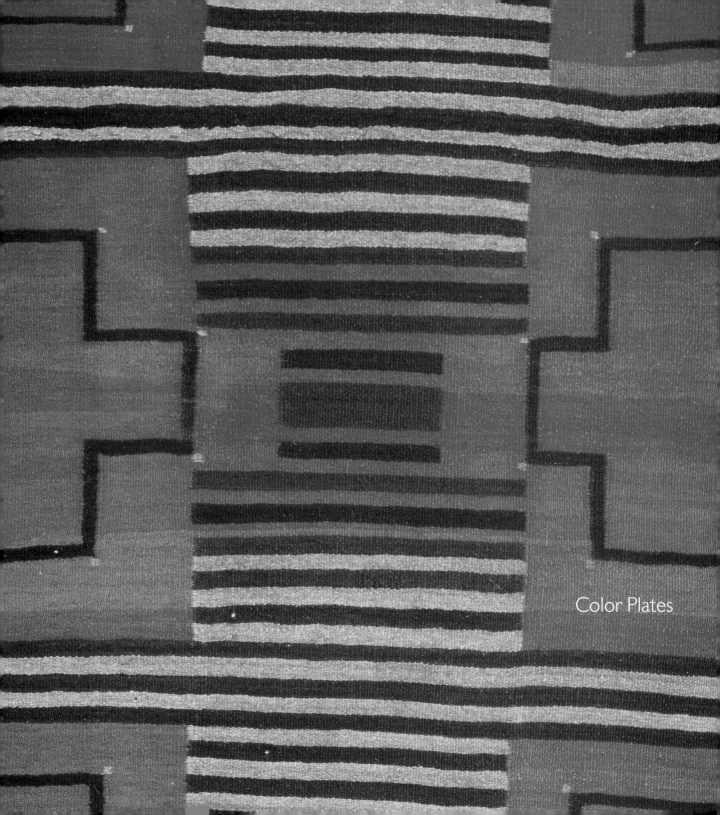

Color Plates

PLATE 1
Pueblo (Zuni?) embroidered
white cotton manta, circa 1875
985-27-10/58896
Handspun cotton warp and weft;
commercial wool embroidery yarns
176.5 × 131 cm

CLAFLIN PURCHASED this beautiful Pueblo ceremonial robe or manta for $25 at a novelty shop on Tremont Street in Boston. Nothing else is known about its history.

The manta is woven in plain weave of handspun cotton and embroidered with three- and four-ply commercial yarns. The presence of both kinds of embroidery yarns suggests that the piece was embroidered in the early to mid-1870s, although the manta itself could be older. Now faded, the embroidery would have been brown, lemon yellow, lime green, orange-red, and bright red when new. Mantas of this type are traditionally made from one of the two white cotton mantas a Pueblo woman receives as part of her wedding trousseau.

The embroidery designs are highly standardized and of ancient origin. Those outlining the upper border represent water or waves, whereas the stacked diamonds of the lower border represent clouds (see details). Many of these same designs appear on ancestral Pueblo pottery and kilts predating European contact.

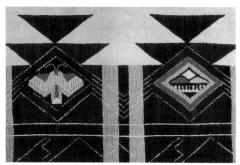

Typically, the only aspect of the embroidery design left to the embroiderer's discretion is the choice of the medallion figures, here decorated with rain clouds, butterflies, and a symbol of the four directions. (Opposite: T3825.2; at left, top: T4012.1; at left, bottom: T3826.1. Hillel S. Burger, photographer.)

Unlike the patterns in traditional Navajo weavings, those in Pueblo ceremonial garments are directly symbolic. This ceremonial cape has a large body of white cotton representing a broad expanse of sky; subtle changes in the warp suggest a gentle rain. In the bottom band, stylized butterflies as symbols of metamorphosis float under stacked cumulus clouds. Aesthetically the garment transforms the wearer into a religious icon. —Tony Berlant (TB)

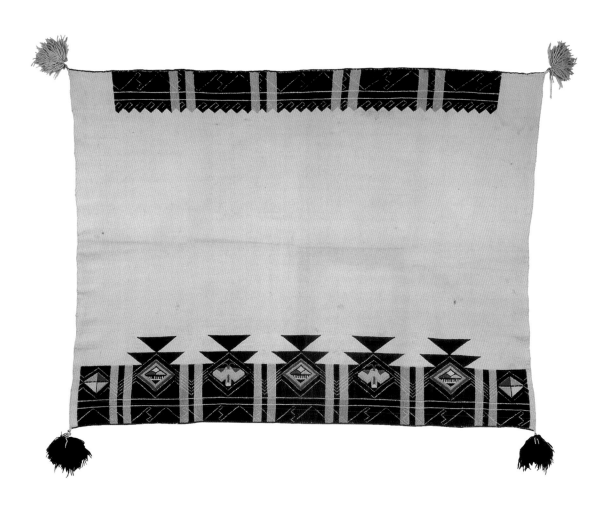

PLATE 2
Zuni black wool manta with blue
embroidered borders, circa 1865–1880
985-27-10/58893
Handspun wool warp and weft;
handspun wool embroidery yarns;
commercial wool stitching yarns
61 x 91 cm (folded, as shown)

CLAFLIN PURCHASED this manta in 1930 from Zuni trader C. G. Wallace for $100. Its blue embroidery against a brown-black background creates a visual effect at once stark and intensely beautiful. The manta is woven in 2/2 twill, except for the plain-weave borders, which are covered by embroidery. Zuni women wore these embroidered mantas as both shawls and dresses. The color combination and embroidery designs are unique to Zuni and served to communicate the cultural identity of the wearer as Zuni.

The manta shown here is embroidered with indigenous stylized butterfly motifs composed of alternating triangles (see detail). In contrast, the naturalistic floral motifs along the borders are of Spanish origin. The manufacture of these mantas declined after 1875 or 1880. If the red, four-ply commercial yarns used to stitch the sides and shoulders of this manta were added about the same time the piece was made, then the manta probably dates around 1875. If they were added later, then the manta could easily date to the 1860s. (Opposite: T3828.1; below: T4013.2. Hillel S. Burger, photographer.)

The primary visual impression one gets from viewing this piece is not that of a rectangle filled with design shapes but rather that of two color fields of close value that vibrate as a single radiant image. —TB

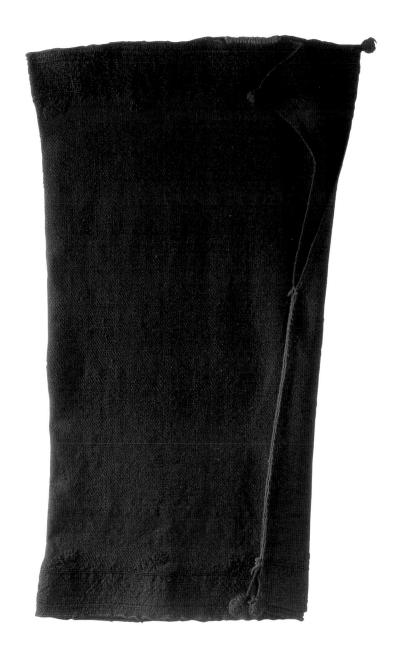

PLATE 3
Hopi plaid wool shoulder blanket,
circa 1937
985-27-10/58931
Handspun wool yarns
153 × 121 cm

THIS HOPI MAN'S wearing blanket was a first-prize winner at the Museum of Northern Arizona's Hopi Craftsman Exhibition in July 1937. A tag formerly attached to the blanket (see below) identifies the weaver as "Se-quop-tewa," from the Hopi village of Hotevilla on Third Mesa. Unfortunately, the weaver's first name is not given, and Sequaptewa is a common surname on Third Mesa. Although the tag says "Not for Sale," Bill Claflin was able to secure the purchase of the blanket.

The blanket is woven of handspun wool yarns worked in diamond twill and 2/2 diagonal twill weaves and is in pristine condition. The presence of the braided tassels partway up the sides shows where the blanket was inverted on the loom during the weaving process. Although plaid blankets are a very old style at Hopi, with archaeological examples predating European contact, they were on the decline at Hopi until the 1930s, when the Museum of Northern Arizona encouraged their revival. Smaller versions of these blankets, woven in plain weave, are still made for young Hopi boys. (Opposite: T3811.1; below: T3813.1. Hillel S. Burger, photographer.)

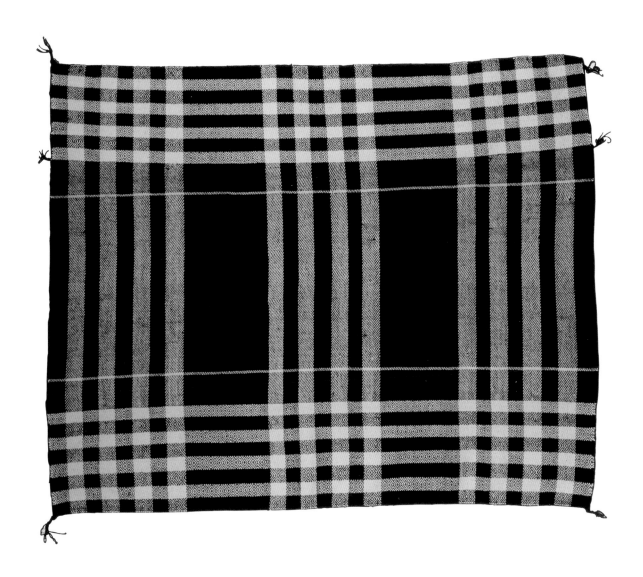

PLATE 4
Two panels of a Navajo woman's dress
(*biil*), circa 1850–1870
985-27-10/58894a and b
Handspun and raveled wool yarns
75.5 x 109 cm (larger panel)

CLAFLIN PURCHASED this textile, along with another two-piece dress, from a curio dealer in Chicago, who in turn acquired the dresses from a unidentified source in western Pennsylvania. In his catalogue Claflin described the dress shown here as the finest example he had ever seen. He believed both dresses to have been made prior to the imprisonment of the Navajo people at Bosque Redondo.

When the two panels of the dress are viewed side by side, as in the accompanying plate, it is easy to see the relationship between the Navajo woman's dress and the Pueblo manta. Why did Navajo women employ the two-piece dress in contrast to the one-piece wraparound manta dress of their Pueblo neighbors? Perhaps their livestock-herding and equestrian lifestyle required greater freedom of movement than that offered by the more-confining wraparound dress. (T3827.1. Hillel S. Burger, photographer.)

Navajo woman's dress, circa 1830–1848
985-27-10/58874a and b
Handspun and raveled wool yarns
81.5 x 123 cm (larger of the two panels)
Acquired by Bill Claflin from artist Andrew Dasburg for $100

Dasburg told Claflin this dress came from the collection of Sterling Price, military governor of New Mexico from 1846 to 1848. If in fact it was collected by Price at that time, then this is probably the earliest piece in the Claflin collection. (T3809.2. Hillel S. Burger, photographer.)

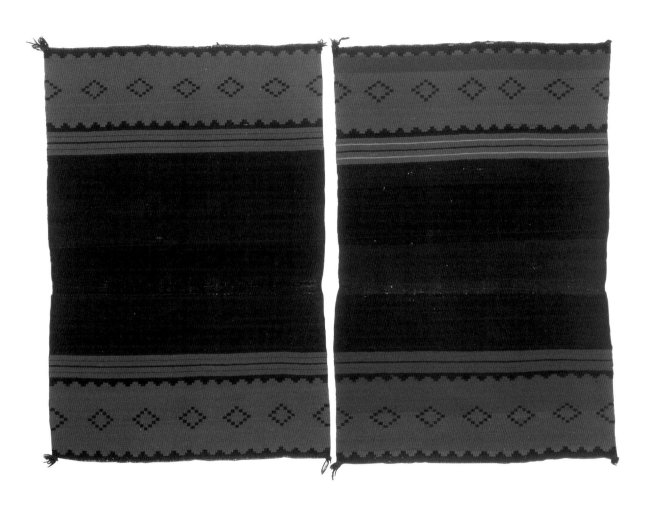

PLATE 5
Navajo first-phase chief blanket,
circa 1800–1860
975-17-10/52911
Handspun wool yarns
186 x 140 cm

THIS BLANKET comes from the William Morris collection, which includes Southwestern textiles collected by both William Morris and General George Crook. Bill Claflin acquired the collection from Morris's widow in 1930. The piece is made entirely of handspun wool, except for some two-ply, machine-spun yarns in the braided tassels. Both these yarns and the tassels appear to be later additions. (T3938.2. Hillel S. Burger, photographer.)

The overall pattern and proportion of the Navajo chief blanket evolved from the striped Pueblo cape, and early chief blankets echo this format. A first-phase chief blanket is always patterned with broad, contrasting bands of deep brown, blue, and cream and, on rare occasion, thin red lines. However, the unique sequences, proportions, and color intensities combine aesthetically so that from afar, the viewer perceives a pulsating field of energy rather than a simple collection of stripes.—TB

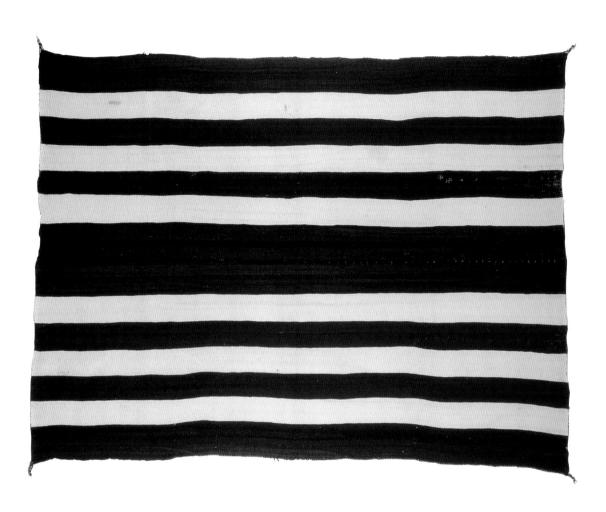

PLATE 6
Navajo second-phase chief blanket,
circa 1860–1865
985-27-10/58880
Handspun and raveled wool yarns
176 × 141 cm

WILLIAM STANLEY HATCH collected this blanket in Colorado sometime between 1860 and 1867 and sent it east to Edmund Trowbridge of Cambridge. The blanket was in Trowbridge's possession by 1870. In 1929, Bill Claflin purchased it from one of Trowbridge's relatives for $150. It is a classic example of the second-phase layout. All yarns are handspun except the red yarns, which are s-spun raveled threads. (T3936.1. Hillel S. Burger, photographer.)

In second-phase chief blankets, blocks appear within the stripes. This heralds an increasing complexity in the Navajo design aesthetic. When a second-phase blanket is worn, two pattern centers become apparent—one at the center of the back and a second in the front where the ends meet when the blanket is wrapped around the body. A viewer would now perceive the blanket pattern as echoing the proportions of the wearer. —TB

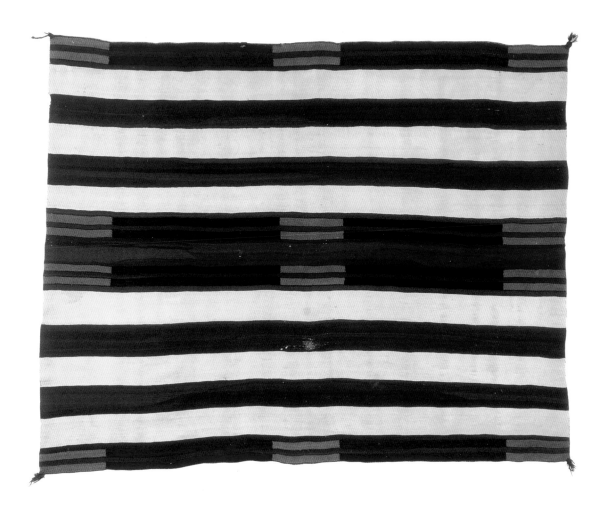

PLATE 7

Navajo modified second-phase
chief blanket, circa 1875
985-27-10/58908
Handspun, raveled, and
commercial wool yarns
174 × 148.5 cm

THIS CHIEF-STYLE BLANKET was collected by Eliza Hosmer, probably between 1890 and 1910. Bill Claflin purchased it from the estate of her sister Abby Hosmer in 1932.

As was typical of the Late Classic period, this blanket contains a diverse mix of commercial and handspun materials. The blue and yellow handspun yarns appear to be colored with vegetal dyes of indigo and a native yellow, whereas the orange yarn suggests an early use of aniline dye. The blanket also contains red yarns of s-spun raveled threads and three-ply Germantown yarn.

The modified second-phase design derives a playful vitality from the use of opposed, striped, T-shaped motifs. A different use of these motifs can be seen on the blanket in plate 14. (T2808.1. Hillel S. Burger, photographer.)

Each Navajo blanket literally grew from the hand and touch of its creator and carried unique, invented details. Daring, unusual inventions occurred especially in the serape form. The recognition that no two blankets are exactly alike has been stressed by many observers. —TB

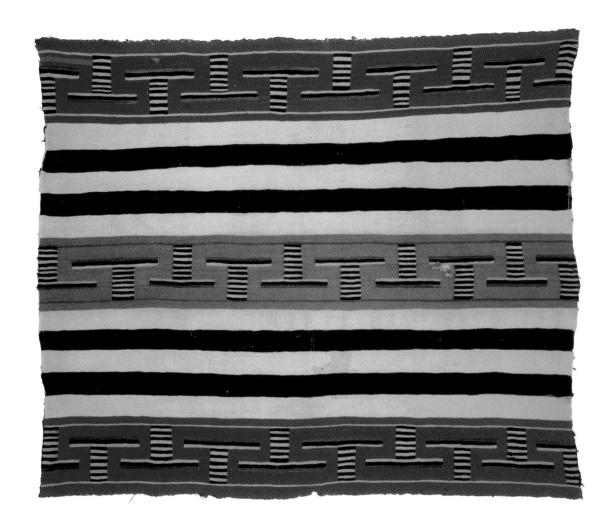

PLATE 8
Navajo modified second-phase
chief blanket, circa 1870–1880
985-27-10/58890
Handspun, raveled, and
commercial wool yarns
180.5 x 150 cm

THIS IS ANOTHER BLANKET from the William Morris collection, which Bill Claflin acquired in 1930. It displays the meander design that became popular among Navajo weavers in the 1870s, when it was used to decorate both chief blankets and serapes. It also exhibits the wide range of materials so common in Late Classic weavings, including handspun yarns colored with native and indigo dyes, three variations of orange–red bayeta, and two kinds of commercial three–ply yarns. (T3931.2. Hillel S. Burger, photographer.)

Paradoxically, although no two blankets are exactly alike, almost all traditional Navajo weavings fit into one of the prescribed forms—second-phase chief, serape, woman's dress, and so on. These formal categories were understood by all members of the tribe, so individual variations and inventions were quickly recognized. It seems remarkable that the Navajos, living for the most part in very small groups, separated by vast distances and with no means of communication other than direct contact, would hold in common prescribed and idealized categories that were constantly changing. Of course a blanket could move from person to person, influencing all who saw it. Overall, a Navajo blanket was a flag of sorts, a manifestation of the power and identity of the culture. —TB

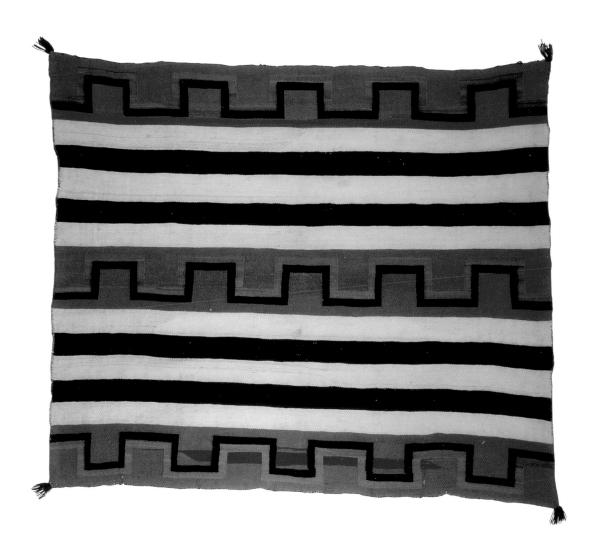

PLATE 9
Navajo third-phase chief blanket,
circa 1860–1870
985-27-10/58901
Handspun, raveled, and
commercial yarns
186 x 125 cm

ANOTHER PIECE collected by Eliza Hosmer, probably between 1890 and 1910, this blanket, too, was purchased by Bill Claflin from the estate of Hosmer's sister Abby in 1932. The weaver seems to have intentionally staggered the diamonds in this blanket to impart a sense of movement. The diamonds would have extended down the wearer's back when the blanket was worn as a robe. In addition to handspun yarns, the blanket also contains three-ply Germantown or Saxony yarns in three shades of red, as well as raveled and respun bayeta and raveled bayeta threads. Note the regular and symmetrical use of lazy lines in this piece, shown in the detail photograph below. (Opposite: T2809.1; below: T3823.1. Hillel S. Burger, photographer.)

Navajo weavers did not work from edge to edge but rather wove in segments determined by the reach of their arms. The process created an underlying pattern delineated by "lazy lines." These shapes form an almost invisible, irregular secondary pattern juxtaposed with the dominant color pattern—a subtle effect that saves the blankets from the mechanical sensibility found in many textile traditions. The effect is especially apparent in the brown bands of Classic-period chief blankets and women's dresses, as well as in the open red backgrounds of Late Classic serapes. The understated value changes within one color along the lazy lines create highly abstracted Navajo landscapes. —TB

The third-phase chief blanket is a synthesis of two Navajo styles, the serape and the second-phase chief blanket. One can see diamonds and half-diamonds—the nine-point format that appears in serapes—overlaid on the earlier chief blanket template. When first introduced, the diamond shapes were small. Gradually they grew in size and importance until they balanced the stripes equally. —TB

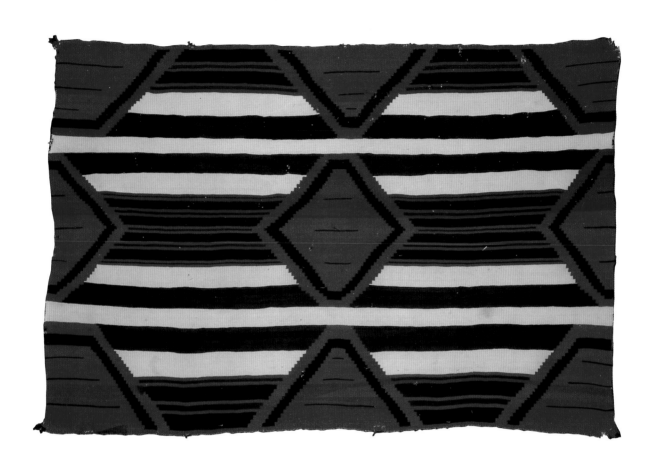

PLATE 10
Navajo fourth-phase chief blanket,
circa 1870-1880
985-27-10/58885
Handspun and raveled wool yarns
160 x 117 cm

THIS BLANKET from the William Morris collection, woven of natural, native, and indigo-dyed handspun yarns and red bayeta threads, has an unusual row of pulled and knotted warps running through one of the white bands, perhaps the result of an early restoration. The bold, oversized diamonds are vertically connected in this blanket, a characteristic feature of the fourth-phase style. The design conveys a dramatic effect when worn, as illustrated in the view opposite (seen from the back). It is little wonder that these abstract designs hold such appeal for modern collectors. (Opposite: T3933.1; below: T4561. Hillel S. Burger, photographer.)

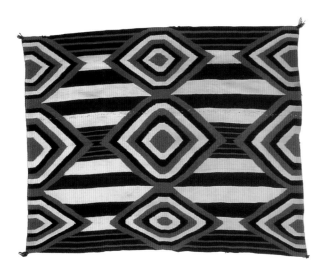

Here, there is no question that the diamonds have become the dominant element in the design. Yet while the stripes initially appear to recede, the effect depends on how a viewer focuses: the stripes can also appear to come forward in the viewer's perception. This animated yin-yang aesthetic is a central aspect of Navajo weaving. —TB

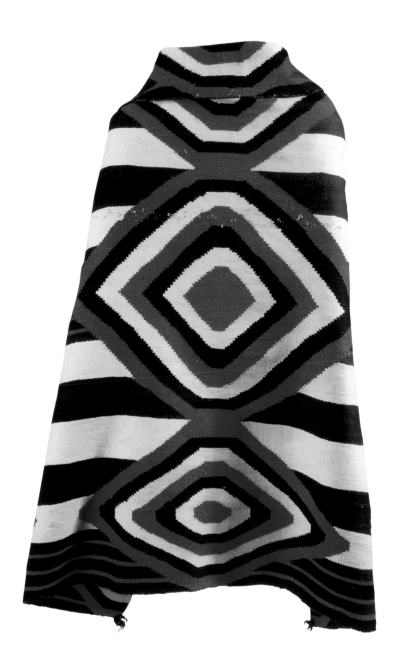

PLATE 11
Navajo woman's modified third-phase
shoulder blanket, circa 1875
985-27-10/58877
Handspun and raveled wool yarns
161.5 x 136 cm

FRANK CLARK collected this blanket on the Shoshone Reservation in Utah in the mid-1870s. Bill Claflin purchased it directly from Clark. The piece is a modified third-phase example using nine cross-within-a square motifs in place of the more typical diamonds, half-diamonds, and quarter-diamonds (see pl. 9). The narrow gray and brown background stripes identify it as a woman's wearing blanket. The blanket contains natural and indigo-dyed handspun and two types of red raveled yarns. It also exhibits an early use of aniline(?)-dyed purple handspun yarns in the selvage cords.

Charles Amsden illustrated this blanket in his 1934 study of Navajo weaving to show the "decadence of the shoulder blanket." From the perspective of the twenty-first century, the blanket is nothing less than a marvel. The viewer is struck not only by its bold design but also by its sheer intensity of color. This blanket elicits an emotional response from all who see it. (T3937.2. Hillel S. Burger, photographer.)

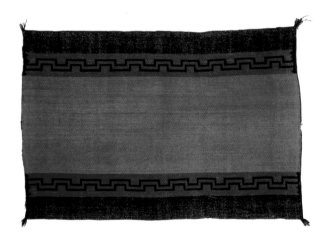

Navajo (or Zuni?) woman's twill shawl, or "fancy manta,"
circa 1865–1875
985-27-10/58888
Handspun and raveled or commercial wool yarns
141 x 94 cm
From the William Morris–George Crook collection

This manta is made with handspun white, indigo blue, and carded orange-pink yarns and with 3z raveled threads or untwisted three-ply Germantown yarn. The center is worked in diagonal twill, the inner borders in twill tapestry, and the outer borders in diamond twill. The edges are twined with three two-ply cords, a selvage configuration more characteristic of Pueblo than of Navajo weaving.

The so-called fancy manta is closely related to certain styles of Pueblo women's shawls. The style became popular in the 1860s and lasted into the 1880s. Historic photographs indicate that these mantas were especially popular among Zuni women. There is little indication that the style was traded to the Plains tribes, so it seems likely that General Crook collected this manta during his time in the Southwest. (T3807.1. Hillel S. Burger, photographer.)

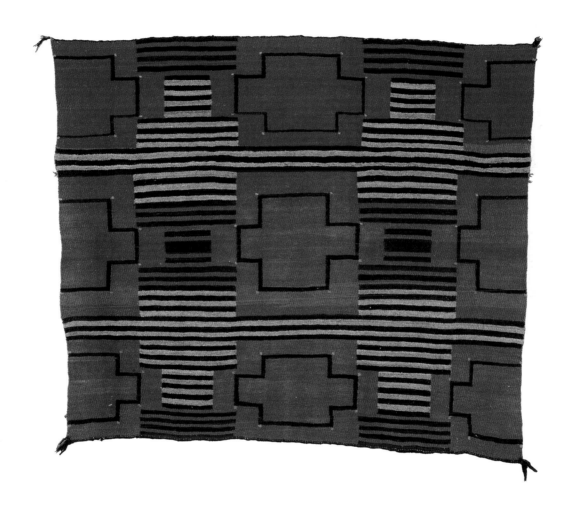

89

Navajo Classic-period serape,
circa 1850–1865
995-2-10/74614
Handspun, raveled, and
commercial wool yarns
119 × 173 cm

THE DOCUMENTATION for this Classic-period serape was lost prior to its accession by the Peabody Museum. One of the oldest and most beautiful pieces in the Claflin collection, it derives its modern appeal from its intensive use of red, its simple yet distinctive design, and its off-center focus. The red yarns include raveled z-spun bayeta and two shades of lustrous three-ply commercial yarns that could be cochineal-dyed Saxony. Natural white and indigo-dyed handspun yarns complete the Classic color palette. (Opposite: T1999; below: T1999A. Hillel S. Burger, photographer.)

A complex and ambiguous image is created with the simple elements of diamonds and stripes. This piece manifests a bold sense of individual invention. Singing special songs while working, the Navajo weaver perceived herself as a conduit for designs dictated by Spider Woman, her vision guide. The Navajos' belief that Spider Woman controlled the weaving of a blanket suggests a link to the Athapaskan shamanism of their ancestors. —TB

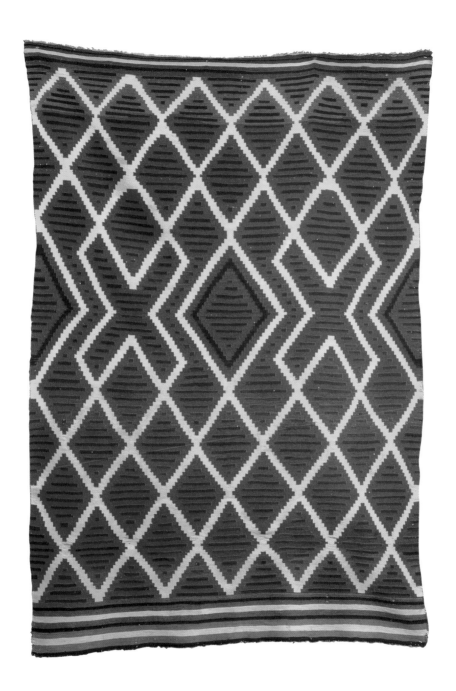

PLATE 13

Navajo Classic-period serape,
circa 1860–1870

975-17-10/52912

Handspun and raveled wool yarns
124 × 198 cm

THIS BLANKET was collected by Henry F. Bond while he was employed as an Indian agent on the Southern Ute Reservation of southwestern Colorado in the 1870s. Claflin acquired it from Bond's nephew, who told him that the blanket had originally been owned by Chief Ouray. Ouray reportedly traded the serape for Mrs. Bond's umbrella as the Bonds were leaving the reservation.

Claflin wrote in his catalogue entry: "Whether or not old Ouray ever saw this blanket, it is one of the finest examples of Navajo weaving I have ever seen. In my opinion undoubtedly made before the Bosque Redondo episode in 1863. I consider it the gem of my collection & I doubt I ever got a better blanket." The serape contains white, indigo blue, and green handspun yarns, red bayeta threads, and yellow and green yarns that could be bayeta or split Saxony. (T3939.2. Hillel S. Burger, photographer.)

To understand the basic Navajo design concept, turn this image so that you are viewing the blanket as a horizontal. Seen in this way, it becomes clear that the design was conceived with an underlying body in mind, rather than simply as a composition within a rectangle. —TB

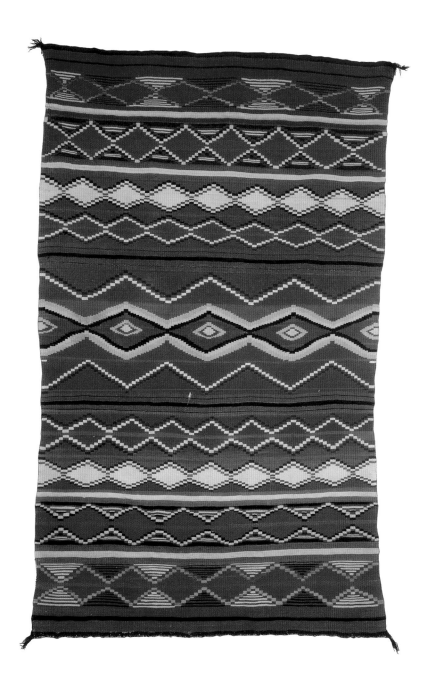

THIS BLANKET, too, was collected by Henry F. Bond on the Southern Ute Reservation in the 1870s, but unlike the case of the serape in plate 13, there is no documentation linking the piece to Chief Ouray.

The alternating T-shaped motifs impart a sense of movement to this serape (see pl. 7 for another use of these elements). All materials are handspun except for the red, which is raveled and respun yarn. The raveled threads used in this piece were "dyed in the cloth," meaning that the cloth was dyed after it was woven. Threads unraveled from this cloth have a speckled appearance where the dye failed to penetrate the yarn. (Opposite: T2813.1; below: T2813.2. Hillel S. Burger, photographer.)

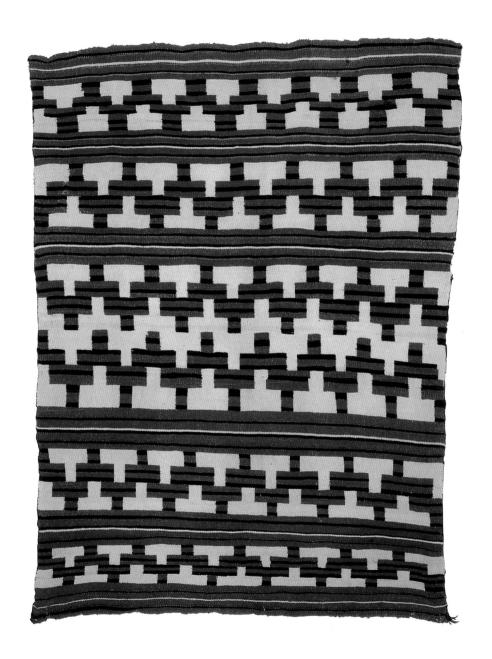

PLATE 15

Navajo Late Classic Germantown
serape, circa 1869–1873
985-27-10/58897
Commercial wool yarns
122 x 200 cm

BOTH THIS SERAPE and the one shown in plate 16 were collected by
Captain Charles A. Hartwell between 1869 and 1873, probably while he
was stationed at Fort Wingate, New Mexico. Hartwell's son wrote that both blankets had been given to his
father by Navajo chiefs. The blankets are in pristine condition and were probably never used.

The serapes shown here and in plate 16 exhibit remarkable similarities in their use of materials. If not
made by the same weaver, they were at least made by weavers with access to many of the same commercial yarns
and yarn palettes. Both are woven entirely of three-ply commercial yarns. Although the colors have long since
faded, the green, gold, and red yarns were originally the same shades in both pieces. The self-fringe on the tex-
tile in plate 15 was produced by leaving the last inch of warp unfilled, then adding a selvage cord and knotting
the unfilled warps. Although not a common feature of Navajo weaving in general, self-fringes are occasionally
found on Late Classic textiles. (T3824.2. Hillel S. Burger, photographer.)

*The weavers who made magnificent blankets like these were specialists who knew they were producing valuable objects that
would be prized by members of other tribes and cultures. A Navajo weaver would not be surprised to learn that 150 years later
her work is sold for the equivalent of many horses. —TB*

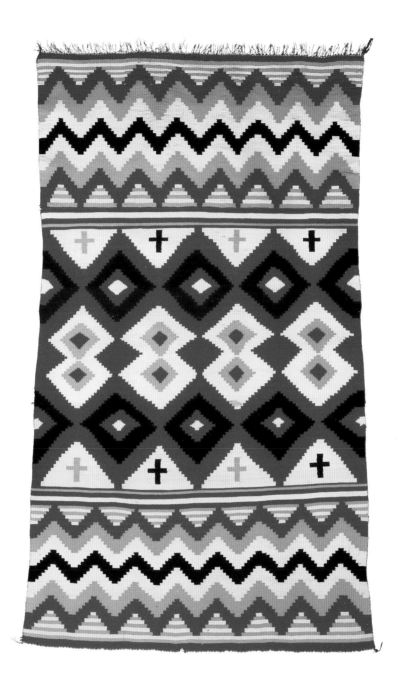

PLATE 16
Navajo Late Classic Germantown
serape, circa 1869–1873
994-33-10/74613
Commercial wool yarns
136.5 x 187 cm

THE DYNAMIC, lightninglike zigzag elements in this serape, the second of two collected by Captain Charles A. Hartwell, seem to express the uncertainties of Navajo life on the new reservation following the return of the Navajo people from Bosque Redondo. Like the serape in plate 15, this one is woven entirely of three-ply commercial yarn. Unlike that serape, this one's warp consists of three-ply commercial yarns (white, brown) with an unusual final Z-twist. The spinner could have started out with three-ply s-spun, Z-twist commercial yarn and simply have tightened the twist, or she could have started with a more common three-ply z-spun, S-twist commercial yarn and retwisted it in the opposite direction. This warp treatment is one of the few technical features differentiating the two textiles. (T3810.1. Hillel S. Burger, photographer.)

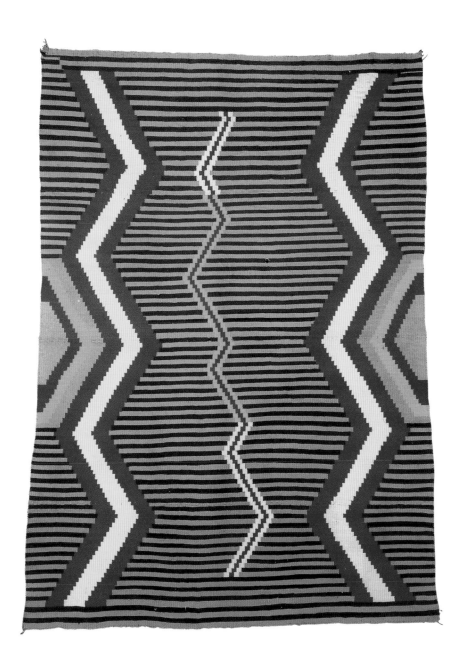

PLATE 17

Navajo or Zuni Late Classic blanket
patterned with "Moqui stripes,"
circa 1875–1880
985-27-10/58889
Handspun wool yarns
117.5 × 159 cm

THIS BLANKET is from the William Morris collection, which includes textiles collected by General George Crook. This style of serape was not regularly traded to the Plains tribes (who greatly favored the chief–style wearing blankets), so the piece could be one of the Morris textiles that was collected by Crook in the Southwest. Certain features of this blanket suggest a possible Pueblo origin. Pueblo blankets tend to be wider in relation to their length (that is, more square) than Navajo ones, a feature seen in this blanket. Also, the symmetry of the design, especially the unusual distribution of "diamond stripes" in the center band (see detail), seems atypical of Navajo weaving. If the blanket is of Pueblo manufacture, then Zuni seems the most likely source. However, it could just as well have been made by a Navajo weaver who chose to do things her own way.

The blanket is made entirely of handspun yarns. My date for the piece is based on the presence of red handspun yarns, which are most likely aniline dyed. (The dyes have not been tested.) Aniline dyes became available to Navajo weavers in the late 1870s. Bill Claflin, too, considered the red color to be a "white man's dye." However, Joe Ben Wheat, who examined the piece in the early 1970s, thought it might be a non–aniline red dye and assigned the weaving an earlier date of 1850–1875. In general, Navajo weavers did not use

cochineal to color their handspun yarns, preferring to unravel red trade cloth instead. However, recent dye analysis suggests that the use of cochineal was not completely unknown among Navajo weavers. (Opposite: T3932.1; at left: T4011.2. Hillel S. Burger, photographer.)

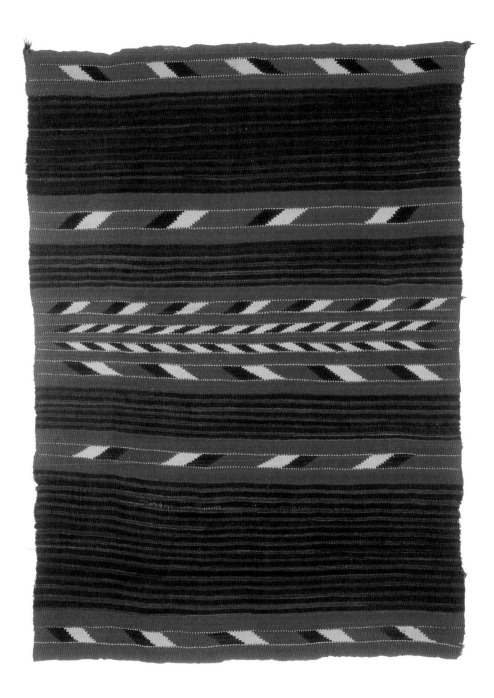

PLATE 18
Navajo Late Classic serape, circa 1875
985-27-10/58906
Handspun and raveled wool yarns, with
commercial yarns in selvage cords
121 X 179.5 cm

AN INDIGO LOVER's delight, this beautiful blanket, originally collected by Eliza Hosmer, probably between 1890 and 1910, underscores Hosmer's fine eye for textiles and one anonymous weaver's exceptional ability with color and design. Eliciting extraordinary depth and contrast from a limited set of colors and raw materials, the weaver made her striped red and dark-blue figures float on a sea of blue (see detail). This is a remarkable and striking piece.

The blanket combines handspun wool in at least five shades of blue with raveled and respun bayeta. Unless the side selvages have been restored, which I do not believe to be the case, the four-ply commercial yarns in the selvage cords suggest a date for the piece in the mid-1870s. (Opposite: T3890.2; below: T3818.2. Hillel S. Burger, photographer.)

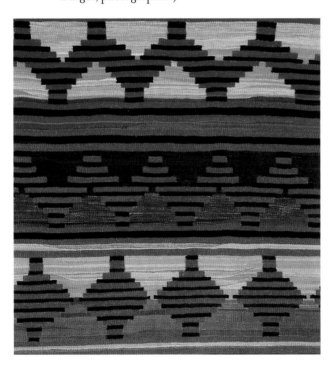

Navajo blankets are abstract representations of the landscape of Navajo country, which imparts a strong sense of horizon and endless sky. Weavers use color and design in powerful and controlled patterns of contrast and affinity to create, in essence, a three-dimensional mandala with scale and proportions linked directly to the body, giving the wearer a feeling of energy and integration with the natural world. —TB

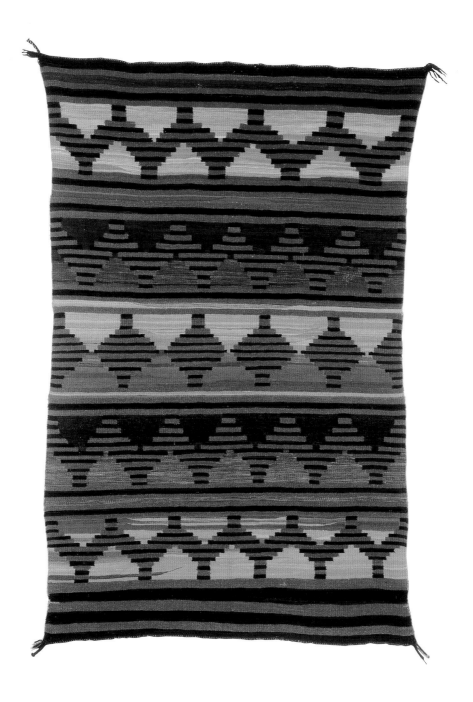

PLATE 19
Navajo Late Classic serape,
circa 1870–1880
985-27-10/58903
Handspun and raveled wool yarn
82 x 130 cm

THIS IS ANOTHER PIECE collected by Eliza Hosmer, probably between 1890 and 1910. In addition to white and indigo blue handspun yarns and three different shades of bayeta (s-spun, z-spun, and raveled and respun), this small serape also contains a distinctive type of handspun yarn known as "carded pink," made by carding white fiber and threads of raveled bayeta together and then spinning them into yarn. The use of carded pink yarn was common in the 1870s, as was the production of small-sized wearing blankets. Although these small blankets are commonly referred to as "child's blankets," they seem to have been made primarily for trade with other Native people and for sale in the emerging Euro-American market. (T3822.1. Hillel S. Burger, photographer.)

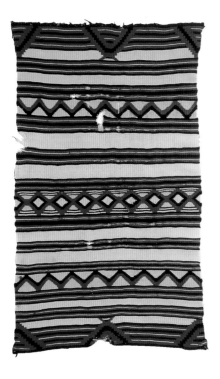

Navajo Late Classic serape, circa 1860–1874
985-27-10/58912
Handspun, raveled, and commercial wool yarns
79 x 132 cm

This is another small-sized blanket in the collection, described by Claflin as a saddle blanket. It was reportedly acquired by W. F. M. Arny in the early 1870s at old Fort Wingate and was in the possession of the Cosgrove family by 1874. Claflin purchased the blanket from the sister of Peabody Museum archaeologist Burt Cosgrove in 1935. The blanket is made from handspun, raveled, and three-ply commercial yarns. (T3941.1. Hillel S. Burger, photographer.)

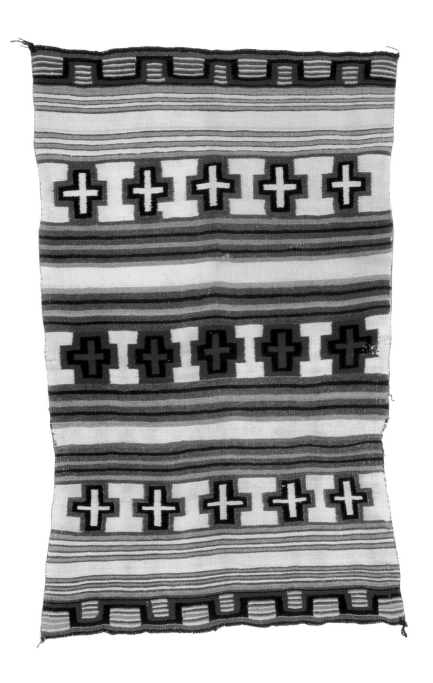

PLATE 20
Navajo Late Classic serape,
circa 1870–1880
985-27-10/58907
Handspun and raveled wool yarns
81 x 122 cm

ANOTHER SMALL-SIZED blanket, this one is made with handspun yarn and a distinctive kind of raveled yarn known as raveled flannel. The fuzziness of the flannel threads lends a blurred appearance to the serrated, or sawtooth, motifs. Navajo weavers adopted these serrated motifs from Mexican Saltillo serapes, not only using them to make their own versions of Saltillo-style weavings but also incorporating them into their banded layouts and all-over designs. This blanket, collected by Eliza Hosmer, probably between 1890 and 1910, is in pristine condition. (T3816.1. Hillel S. Burger, photographer.)

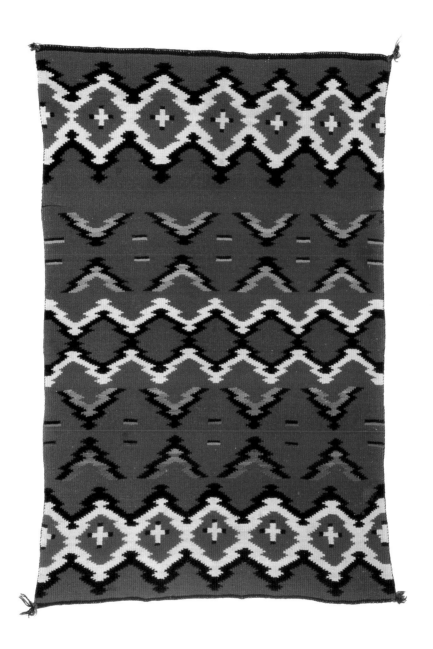

PLATE 21
Navajo Late Classic/Transitional
serape, circa 1880
985-27-10/58904
Handspun wool yarns
76.5 x 125 cm

WHAT MAKES this small serape or saddle blanket, again collected by Eliza Hosmer, so striking is its color palette, especially the unusually bright shades of blue, probably derived from indigo (see detail). The blues and greens and the contrasting beaded edging of the blue stripes suggest the pastel hues and designs used by Hispanic weavers in the Rio Grande Valley of New Mexico during the late nineteenth century. This blanket was definitely woven on a Navajo loom, but one wonders whether the weaver might not have been exposed to Rio Grande weavings at some point in her life. The materials are all handspun and appear to have been colored with indigo and aniline dyes. (Opposite: T3820.1; below: T3821.1. Hillel S. Burger, photographer.)

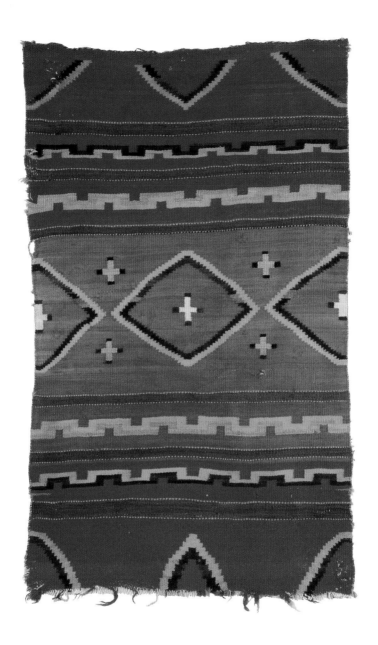

PLATE 22
Navajo Late Classic/Transitional
serape patterned with "Moqui stripes,"
circa 1875–1885
985-27-10/58913
Handspun and commercial
wool yarns
136 x 197 cm

COLLECTED BY Rowland Gibson Hazard II, probably in the 1890s, this blanket was acquired by Claflin around the mid–1930s. He obtained it through the efforts of Harvard archaeologist A. V. Kidder, who saw the blanket hanging from the window of one of the student dormitories on campus. It is woven almost entirely of handspun yarns, except for the red yarns, which are aniline-dyed, four-ply commercial yarns. In this weaving the Moqui stripes are relegated to the background of the design. (T2802. Hillel S. Burger, photographer.)

Navajo blankets employ design motifs that are found in textile traditions around the world. Yet in the hands of Navajo weavers, these shapes acquire a vitality that sets them apart. Their overall effect is that of an abstracted energy field.

Navajo blankets resonate with the power of innate mental forms. Studies by perceptual psychologists have demonstrated that when people are placed in a sensory-deprived environment—for example, floating in the dark—they perceive forms directly from their neurology. These forms include nested rectangles and wavy parallel lines. Although the designs in Navajo weavings can be seen to have evolved from Pueblo, Spanish, and Mexican influences, they carry an energy and plasticity of much greater force than is found in these traditions. Perhaps the intensity of these shapes, produced while the weavers chanted special songs and experienced Spider Woman as directing their designs, resulted from their making unconscious contact with underlying neurological patterns. —TB

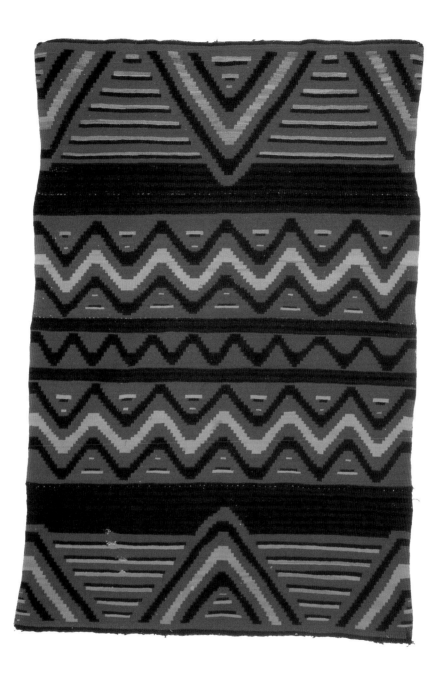

PLATE 23
Navajo Transitional wedge-weave
blanket, circa 1875–1885
985-27-10/58884
Handspun and commercial
wool yarns
132 x 181 cm

THIS PIECE, from the William Morris collection, is woven of handspun wool yarns colored with indigo, native(?) black, and aniline red and orange dyes, along with three- and four-ply commercial yarns. The presence of both kinds of commercial yarns suggests a post-1874 date for the blanket.

Navajo weavers practiced this eccentric wedge-weave, or pulled-warp, technique from the late 1870s until around 1890. The diagonal and zigzag designs were produced by inserting the wefts at an angle, thus forcing the warps out of vertical alignment. This distortion can be seen in the detail photo, in which the warps bend first in one direction, then in the other, producing a chevron motif. Blankets made in this technique are also identified by their characteristic scalloped edges. (Opposite: T3934.2; below: T3935.1. Hillel S. Burger, photographer.)

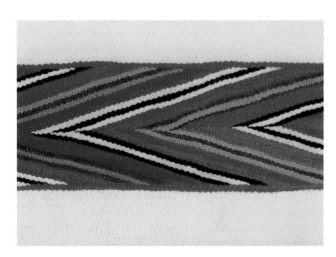

Scholars have long thought that the scalloped edges of pulled-warp blankets were merely the unavoidable result of a time-saving weaving technique. I have come to believe, however, that weavers did this at least in part because they liked the effect of scalloped edges, which softened the rigidity of the traditional rectangular blanket shape and imbued the blanket itself with the pulsating energy of the design. —TB

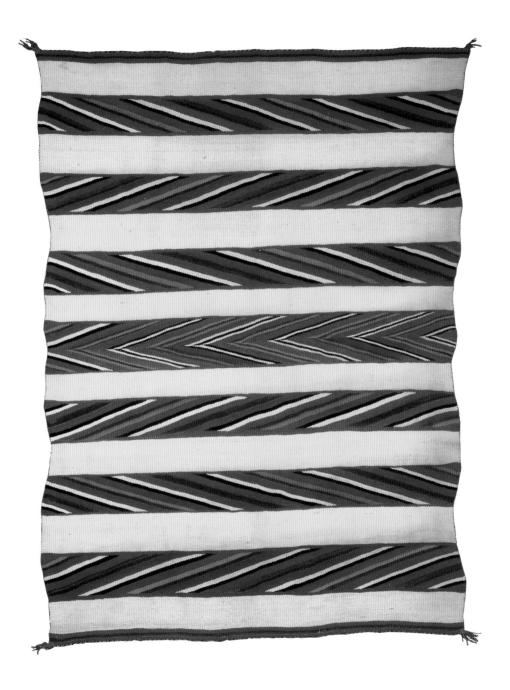

113

PLATE 24
Navajo Hubbell revival rug, circa 1896
985-27-10/58879
Handspun, raveled, and commercial
wool yarns
139.7 x 220.5 cm

THIS BLANKET was reportedly woven for Juan Lorenzo Hubbell around 1896 using English trade cloth imported expressly for the purpose. According to Charles Amsden, Hubbell's motive in commissioning the blanket was to demonstrate that the raveled bayeta technique was not yet lost. For many years the blanket hung on the wall of Hubbell Trading Post, but in 1923 Hubbell put it up as collateral on a loan. Claflin bought it from the lender, Mike Quirk (probably Mike Kirk) of Gallup, New Mexico, for $150.

In 1930 Claflin learned the story of the blanket from Herman Schweizer of the Fred Harvey Company. According to Schweizer, in the 1890s he had loaned Hubbell an old blanket for use as a model, from which three bayeta weavings were made. Schweizer's model is believed to be the Late Classic serape shown below, now in the collections of the Maxwell Museum of Anthropology.

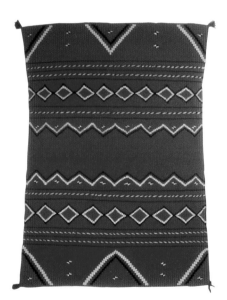

The warp of Claflin's revival–style blanket is probably a commercial 4z–S yarn that has been respun 4s–S. The white and black yarns are handspun wool. The red is a fuzzy, raveled flannel bayeta, with the threads used in groups of three and four, some having an s spin, others a z spin. Evidently the blanket was never used, because loose threads still cover the entire surface. Claflin remarked in his catalogue that "a poor job was done in unraveling the flannel, many of the threads being woven into this blanket without being completely untwisted." (T1216. Hillel S. Burger, photographer.)

Navajo Late Classic serape, circa 1875
Commercial two-, three-, and four-ply wool yarns
Photo courtesy of the Maxwell Museum of Anthropology,
University of New Mexico, catalogue number 63.34.151.

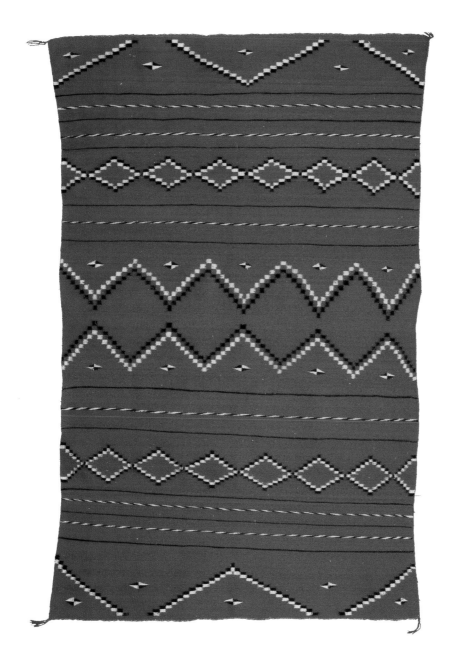

PLATE 25
Navajo Chinle revival rug,
circa 1925–1935
985-27-10/58925
Handspun wool yarns
125 x 183 cm

THE COLLECTION HISTORY of this textile is unknown. No Claflin number is associated with it, nor did Bill Claflin describe it in his blanket catalogue. At first glance, it appears to be a Transitional banded blanket, but on closer inspection the texture and colors differ significantly from those found in nineteenth-century weavings. The blanket is most likely a Chinle revival piece. An inventory list of Claflin's collection indicates that he purchased at least two blankets from Cozy McSparron's trading post at Chinle, so it is known that he was familiar with McSparron's establishment.

The blanket consists entirely of handspun wool, in shades of natural white and blended gray, native brown, indigo or synthetic blue, and synthetic orange-red. The red and perhaps also the blue are probably colored with DuPont dyes. (T3806.3. Hillel S. Burger, photographer.)

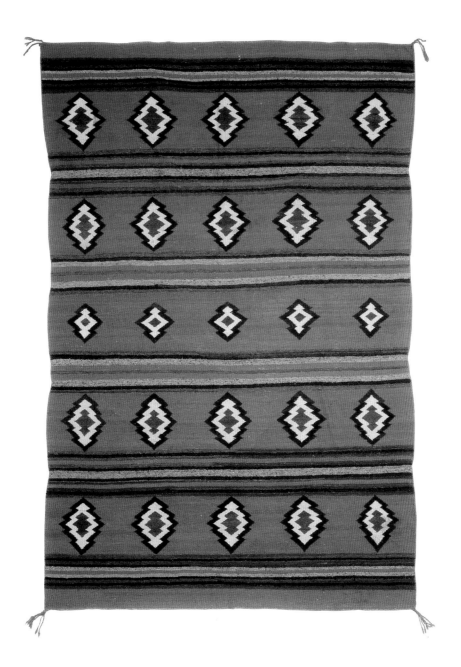

117

APPENDIX

PLATE 1. PM 985-27-10/58896 (Claflin 34567). Warp: handspun cotton, z, natural white, 7–9/cm. Weft: handspun cotton, z, natural white, 4–5/cm. End selvage cords: handspun cotton, natural white, three strands 2z–S, twined S-wise and Z-wise (?, obscured by overcasting). Side selvage cords: handspun cotton, natural white, three strands 2z–S, twined S-wise. Upper tassels: augmented, handspun cotton, z, natural white, intermixed with commercial wool, 4z–S, synthetic orange. Lower tassels: augmented, handspun wool, z, native(?) black. Embroidery yarns: commercial wool, 3z–S, native brown and synthetic orange-red, used as three strands; commercial wool 4z–S, synthetic or vegetal lime green and lemon yellow (both faded), synthetic red, used as two strands.

PLATE 2. PM 985-27-10/58893 (Claflin 34517). 2/2 balanced twill center panel with plain-weave borders. Warp: handspun wool, z, probably native brown-black, 7–8/cm. Weft: handspun wool, z, probably native brown-black, 7/cm. End and side selvage cords: handspun wool, probably native brown-black, three strands 2z–S, twined Z-wise. Corners: selvage cords wound into tassels. Embroidery yarn: handspun wool, z, probably indigo blue, worked in historic Pueblo embroidery stitch (geometric elements) and satin stitch (floral elements).

Note: None of the dyes has been tested scientifically. See glossary for an explanation of yarn notations.

Stitching yarn: commercial wool, 4z–S, synthetic scarlet red, worked in double blanket stitch at sides, interlacing figure–eight pattern at shoulders.

PLATE 3. PM 985-27-10/58931 (no Claflin number). Diamond twill weave and 2/2 diagonal twill weave. Warp: handspun wool, z, natural white and native or synthetic brown–black, 8–9/cm. Weft: handspun wool, z, natural white and native or synthetic brown–black, 6–8/cm. End and side selvage cords: handspun wool, native or synthetic brown–black, three strands 2z–S, twined S–wise. Tassels: selvage cords braided into tassels at corners and at sides where blanket was turned on loom.

PLATE 4. PM 985-27-10/58894a and b (Claflin 34565). Warp: handspun wool, z, natural white, 5–6/cm. Weft: handspun wool, native brown, indigo blue, probably indigo + vegetal = teal blue, 32–40/cm; raveled wool, 2s, lac, cochineal, or synthetic crimson and dark crimson, 20–28/cm; raveled wool, 2Z, probably indigo + vegetal = yellow–green, 22–26/cm. End and side selvage cords: handspun wool, indigo blue, two strands 3z–S, twined S–wise. Corners: augmented tassels.

PLATE 4, INSET. PM 985-27-10/58874a and b (Claflin 24532). Warp: handspun wool, z, natural white, 4/cm. Weft: handspun wool, z, native brown–black, indigo blue, 19–23/cm.; raveled wool, 2Z, cochineal or lac, salmon pink, 30–36/cm; raveled wool, 2s and 3s, cochineal or lac, crimson red, 21–28/cm. End selvage cords: handspun wool, indigo blue, one end has two strands 3z–S, other has rolled hem, both covered by overcasting. Side selvage cords: handspun wool, indigo blue, two strands 3z–S, covered by overcasting. Corners: tassels missing.

PLATE 5. PM 975-17-10/52911 (Claflin 34509). Warp: handspun wool, z, natural white, 3/cm. Weft: handspun wool, natural white and brown, indigo blue, 20/cm. End selvage cords: handspun wool, indigo blue, two strands 2z–S, twined Z–wise. Side selvage cords: handspun wool, indigo blue, two strands 2z–S, twined S–wise and Z–wise. Corners: selvage cords braided into tassels with added commercial two–ply (split Germantown?) red and blue yarns; probably a later addition.

PLATE 6. PM 985-27-10/58880 (Claflin 24799). Warp: handspun wool, z, natural white and brown, 5/cm. Weft: handspun wool, z, natural white and brown, indigo blue, 26–30/cm; raveled wool, s, cochineal or lac(?) crimson red. End selvage cords: handspun wool, indigo

blue, two strands 3z–S. Side selvage cords: handspun wool, indigo blue, two strands 3z–S. Corners: augmented tassels.

PLATE 7. PM 985-27-10/58908 (Claflin 34582). Warp: handspun wool, z, natural white, 3–4/cm. Weft: handspun wool, z, natural creamy white, native brown, probably vegetal pale yellow, indigo blue, probably indigo + vegetal = pale blue–green, synthetic(?) orange, 13–20/cm; raveled wool, 4S, synthetic(?) crimson red, 20–22/cm; commercial wool, 3z–S, synthetic(?) crimson red, 20–21/cm. End selvage cords: handspun wool, indigo blue, two strands 3z–S, twined S-wise. Side selvage cords: handspun wool, indigo blue, two strands 3z–S, twined S-wise and Z-wise. Corners: tassels missing.

PLATE 8. PM 985-27-10/58890 (Claflin 34513). Warp: handspun wool, z, natural white, 3–4/cm. Weft: handspun wool, z, natural white, probably native brown–black, indigo blue, probably indigo + vegetal = green, 13–19/cm; raveled and respun wool flannel, z, synthetic dark orange–red, 15/cm; raveled wool, 2s, synthetic light orange–red, 17/cm; raveled and respun wool, z, synthetic orange–red (speckled), 17–20/cm; commercial wool, 3s–Z, synthetic orange–red, 19/cm; commercial wool, 2(3z–S), synthetic dark red, 15–16/cm. End selvage cords: handspun wool, indigo blue, two strands 3z–S, twined S-wise. Side selvage cords: handspun wool, indigo blue, two strands 2z–S, some twined S-wise (remainder missing). Corners: restored tassels.

PLATE 9. PM 985-27-10/58901 (Claflin 34574). Warp: handspun wool, z, natural white, 4–5/cm. Weft: handspun, z, natural white, natural or native brown, indigo blue, 18–20/cm; raveled wool, z, lac, cochineal, or synthetic crimson red, 15–16/cm; raveled wool, s (used in groups of 3–7), lac, cochineal, or synthetic crimson red, 17–20/cm; commercial wool, 3z–S, lac, cochineal, or synthetic crimson red, 20–21/cm. End and side selvage cords: handspun wool, indigo blue, two strands 2z–S, twined S-wise and Z-wise. Corners: augmented tassels; one tassel has some olive brown, 4–ply commercial wool worked in.

PLATE 10. PM 985-27-10/58885 (Claflin 34506). Warp: handspun wool, z, natural blended gray, 3–4/cm. Warp: handspun wool, z, natural white, probably native brown, indigo blue, 19–26/cm; raveled wool, 3s, synthetic(?) rose red, 22–24/cm. End selvage cords: handspun wool, indigo blue, two strands 3z–S, twined Z-wise. Side selvage cords: handspun wool, indigo blue, two strands 3z–S, twined S-wise and Z-wise. Corners: augmented tassels.

PLATE 11. PM 985-27-10/58877 (Claflin 24793). Warp: handspun wool, z, natural white, 3.5/cm. Weft: handspun wool, z, natural blended gray, probably native brown-black, indigo blue, probably indigo + vegetal = green, 18–20/cm; raveled and respun wool flannel, z, synthetic red, 20/cm; raveled wool, 3s, synthetic orange-red, 16/cm. End selvage cords: handspun wool, indigo blue, two strands 3z–S, twined S-wise. Side selvage cords: handspun wool, natural gray, probably synthetic purple, two strands 3z–S, twined S-wise. Corners: augmented tassels.

PLATE 11, INSET. PM 985-27-10/58888 (Claflin 34510). 2/2 balanced twill center panel with twill-tapestry and diamond-twill borders. Warp: handspun wool, z, natural white, 8–9/cm. Weft: handspun wool, z, indigo blue, carded natural + synthetic(?) raveled red = orange-pink, 9–11/cm; raveled 3z, or untwisted 3z–S commercial yarn, synthetic(?) scarlet red, 14–15/cm. End selvage cords: handspun, indigo blue, three strands 2z–S, twined Z-wise. Side selvage cords: handspun, indigo blue, three strands 2z–S, twined S-wise and Z-wise. Corners: augmented tassels.

PLATE 12. PM 995-2-10/74614 (no Claflin number). Warp: handspun wool, z, natural white, 5–6/cm. Weft: handspun wool, z, natural off-white, indigo blue (two shades), 23–27/cm; raveled wool, 2Z, probably cochineal or lac(?) cherry red, 33–35/cm; commercial wool, 3z–S, probably cochineal or lac(?) cherry red and salmon pink, 22–28/cm. End and side selvage cords: handspun, indigo blue, two strands 3z–S, twined S-wise (selvage cord missing from one end). Corners: tassels missing.

PLATE 13. PM 975-17-10/52912 (Claflin 24794). Warp: handspun wool, z, natural white, 7/cm. Weft: handspun wool, z, natural white, indigo blue, probably indigo + vegetal = blue-green, probably vegetal yellow, 28–32/cm; raveled wool, 28–44/cm; raveled wool, z and 2Z, probably indigo + vegetal = green, probably vegetal yellow, probably synthetic(?) crimson and pink, 28–44/cm. Alternatively, green and yellow could be strands of a commercial yarn. End selvage cords: handspun wool, indigo blue, two strands 3z–S. Side selvage cords: handspun wool, indigo blue, two strands 2z–S, twined S-wise. Corners: augmented tassels, some strands worked into a braid.

PLATE 14. PM 985-27-10/58878 (Claflin 24797). Warp: handspun wool, z, natural white and brown, 3.5/cm. Weft: handspun wool, z, natural white, medium and dark indigo blue, 10–16/cm; raveled and respun wool, z, synthetic or cochineal crimson red, 14–16/cm.

End selvage cords: raveled and respun wool, synthetic or cochineal crimson red, two strands 3z–S, twined S–wise and Z–wise. Side selvage cords: raveled and respun wool, synthetic or cochineal crimson red, two strands 3z–S, twined S–wise and Z–wise. Corners: one augmented tassel; three missing.

PLATE 15. PM 985-27-10/58897 (Claflin 34568). Warp: commercial wool, 3z–S, vegetal or synthetic gold, 4/cm. Weft: commercial wool, 3z–S, natural white, probably synthetic blue-green (faded to pea green), scarlet red, black, 19–26/cm. End selvage cords: commercial wool, two strands 3(3z–S)S, twined S–wise; one end also finished in a self-fringe with warps tied in overhand knots. Side selvage cords: commercial wool, two strands 3(3z–S)S, twined S–wise and Z–wise. Corners: side cords tied around end cords.

PLATE 16. PM 994-33-10/74613 (Claflin 34569). Warp: commercial wool, 3z–Z(?) (respun?), natural white and brown, 4–5/cm. Weft: commercial wool, 3z–S, natural white, natural or synthetic olive brown, probably synthetic yellow-green, orange-gold, and scarlet red, 20–21/cm. End selvage cords: commercial wool, probably synthetic yellow-green, three strands 3(3z–S)S, twined S–wise. Side selvage cords: commercial wool, probably synthetic yellow-green, three strands 3(3z–S)S, twined S–wise and Z–wise. Corners: end cords still knotted together at two corners, but tassels mostly missing.

PLATE 17. PM 985-27-10/58889 (Claflin 34512). Warp: handspun wool, z, natural white, 3–4/cm. Weft: natural white, native black, indigo blue (two shades), probably synthetic crimson red, 12–20/cm. End selvage cords: handspun wool, indigo blue, mostly worn away. Side selvage cords: handspun wool, indigo blue, two strands 3z–S, twined S–wise and Z–wise. Corners: augmented tassels.

PLATE 18. PM 985-27-10/58906 (Claflin 34580). Warp: handspun wool, z, natural white and blended gray, 3–4/cm. Weft: handspun wool, z, indigo blue in five different shades, 14–18/cm; raveled and respun wool, z, probably synthetic cherry red, 14–18/cm. End selvage cords: handspun wool, dark indigo blue, two strands 3z–S, twined Z–wise. Side selvage cords: commercial wool, indigo(?) blue, two strands 3(4z–S)Z, twined S–wise and Z–wise. Corners: intact corner has two braided tassels; other corners have partial braids.

PLATE 19. PM 985-27-10/58903 (Claflin 34576). Warp: handspun wool, z, natural white, 3–4/cm. Weft: handspun wool, z, natural white (some used in pairs), indigo blue (two

shades), synthetic(?) red + natural white = carded pink, synthetic(?) pale orange (used in pairs), 13–27/cm; raveled and respun wool, z, synthetic(?) cherry red, 19–21/cm; raveled wool, 3s, synthetic(?) dark crimson red, 19–23/cm. End selvage cords: handspun wool, indigo blue, two strands 3z–S, twined Z–wise. Side selvage cords: handspun wool, indigo blue (two shades), one strand 2z–S, other strands 3z–S, twined S–wise and Z–wise. Corners: augmented tassels.

PLATE 19, INSET. PM 985-27-10/58912 (Claflin 34590). Warp: handspun wool, z, natural white. Weft: handspun wool, natural white and indigo blue; raveled bayeta yarn; commercial three–ply Germantown or Saxony yarn, cochineal, lac, or synthetic red. Thread counts and selvage cord information unavailable.

PLATE 20. PM 985-27-10/58907 (Claflin 34581). Warp: handspun wool, z, natural white, 3–4/cm. Weft: handspun wool, z, natural white, indigo blue, probably indigo + vegetal = green (several shades), 14–20/cm; raveled wool flannel, 2s and 3s, probably synthetic scarlet red, 19–24/cm. End selvage cords: handspun wool, indigo blue, two strands 3z–S, twined S–wise. Side selvage cords: handspun wool, indigo blue, two strands 3z–S, twined Z–wise. Corners: end and side cords tied together at corners; the red four–ply commercial yarn tied into all four tassels may be a later addition.

PLATE 21. PM 985-27-10/58904 (Claflin 34577). Warp: handspun wool, z, natural white and blended gray, 3–4/cm. Weft: handspun wool, z, natural white, medium indigo blue, probably indigo + vegetal = light blue–green and dark green, probably synthetic goldenrod, probably synthetic orange–red, 14–22/cm. End selvage cords: handspun wool, one strand medium indigo blue 3z–S, other strand synthetic(?) goldenrod 3z–S, twined S–wise (one end missing). Side selvage cords: handspun wool, one strand synthetic(?) goldenrod 3z–S, other strand probably synthetic faded orange, 3z–S, twined S–wise and Z–wise. Corners: tassels missing.

PLATE 22. PM 985-27-10/58913 (Claflin 34594). Warp: handspun wool, z, natural white, 4–5/cm. Weft: handspun wool, z, probably native brown, indigo blue, probably indigo + vegetal = gold–green, 15–20/cm; commercial wool, 4z–S, probably synthetic scarlet red, 17–20/cm. End selvage cords: handspun wool, indigo blue, two strands z, twined Z–wise. Side selvage cords: handspun wool, indigo blue, two strands z, twined S–wise and Z–wise. Corners: end and side cords tied together at corners.

PLATE 23. PM 985-27-10/58884 (Claflin 34505). Warp: handspun wool, z, natural white, 3/cm. Warp: handspun wool, z, natural white, probably indigo + vegetal = blue–green, native or synthetic black, synthetic red and orange, 7–10/cm; commercial wool, 2(3z–S), synthetic navy blue (faded to purple), 11–12/cm; commercial wool, 2(4z–S), synthetic(?) blue–green, 9–10/cm. End selvage cords: handspun wool, indigo blue, two strands 3z–S, twined Z–wise; handspun wool, synthetic red, two strands 3z–S, twined Z–wise. Side selvage cords: handspun wool, synthetic red, two strands 2z–S, twined S–wise. Corners: augmented tassels.

PLATE 24. PM 985-27-10/58879 (Claflin 24798). Warp: commercial wool, 4s–S, natural white, 4–5/cm. Weft: handspun wool, z, natural white and probably synthetic black, 20–22/cm; raveled wool flannel, z, 3s, 4S, synthetic crimson red, 12/cm. End selvage cords: raveled wool flannel, synthetic crimson red, two strands 2(6s–Z)S, twined Z–wise. Side selvage cords: raveled wool flannel, synthetic crimson red, two strands 2(6s–Z)S, twined S–wise and Z–wise. Corners: self tassels.

PLATE 25. PM 985-27-10/58925 (no Claflin number). Warp: handspun wool, z, natural white, 4–5/cm. Weft: handspun wool, z, natural white, natural blended gray, native or synthetic dark brown, indigo or synthetic medium blue, synthetic orange–red, 8–11/cm. End selvage cords: handspun wool, synthetic orange–red, two strands 3z–S, twined Z–wise. Side selvage cords: handspun wool, synthetic orange–red, two strands 2z–S, twined S–wise and Z–wise. Corners: side cords tied around end cords.

FIGURE 16, LEFT. PM 985-27-10/58922 (no Claflin number). Warp, handspun wool, z, natural white. Weft: handspun wool, z, natural white, blended gray, native or synthetic brown–black, native or synthetic gold, synthetic red. Thread counts and selvage information unavailable.

FIGURE 16, RIGHT. PM 985-27-10/58927 (no Claflin number). Warp: commercial cotton string. Weft: handspun wool, z, synthetic dark orange and lavender; commercial wool, 4z–S, natural white, synthetic black, light orange, red; yellow band at one end is composed of groups of threads or strips of rags. Thread counts and selvage information unavailable.

Notes

1. Much of the biographical information about William H. Claflin Jr. presented in this essay was supplied to me by Claflin's daughter, Mrs. Anne Allen, who graciously shared excerpts from her father's unpublished autobiography and biographical information compiled by Claflin family members.

2. Ross G. Montgomery, Watson Smith, and John O. Brew, *Franciscan Awatovi* (Cambridge, MA: Papers of the Peabody Museum of American Archaeology and Ethnology, vol. 36, 1949), vii. Brew acknowledged Claflin in all of the Awatovi volumes. He also wrote about Claflin's involvement with the Awatovi project in his memoir, "The Excavation of Awatovi," in *Camera, Spade, and Pen: An Inside View of Southwestern Archaeology,* compiled by Marc Gaede and Marnee Gaede (Tucson: University of Arizona Press, 1980), 103–109. A complete history of the Awatovi Expedition, written by Hester Davis, is forthcoming from the Peabody Museum Press.

3. A complete list of the Awatovi Expedition staff and crew members is given on page ix of the Franciscan Awatovi report. The catalogue number of the Awatovi diorama is PM 996–26–10/75391.

4. Anne Claflin Allen, personal communication.

5. Amsden illustrated examples of Claflin's blankets in plates 61, 75, 98a, 100, 102, and 106 of his *Navaho Weaving: Its Technic and History* (Los Angeles: Southwest Museum; reprint, Glorieta, NM: Rio Grande Press, 1982) and mentioned another on page 143, note 11. Except for the textile in plate 98a, all are now in the collections of the Peabody Museum. Amsden also illustrated in plate 61a some fragments of Navajo textiles that Claflin excavated during archaeological work in Canyon del Muerto, Arizona, in 1920. In *The Navajo Blanket* (Westport, CT: Praeger, 1972), Kahlenberg and Berlant illustrated Claflin textiles in plates 9, 17, 33, 37, and 40. All except that shown in plate 40 are now at the Peabody Museum. See also Berlant and Kahlenberg, *Walk in Beauty* (Boston: New York Graphic Society, 1977), figures 17, 22, and 48 and plates 1 and 31. Ann Lane Hedlund has recently edited and expanded upon Joe Ben Wheat's major study of Southwestern weaving, *Blanket Weaving in the Southwest* (Tucson: University of Arizona Press, 2003).

6. One of the best sources of information about the U.S. Indian agents and their agencies is the *Annual Report of the Commissioner of Indian Affairs to the Secretary of the Interior* (Washington, DC: Government Printing Office). Unfortunately, none of the 1870s reports by Indian agents to the Utes or Shoshones includes the names of reservation employees, so it is unknown whether Frank Clark was a government employee or worked there in some other capacity. I have found no evidence to indicate that Clark was an Indian agent.

7. Myra Jenkins and Albert H. Schroeder, *A Brief History of New Mexico* (Albuquerque: University of New Mexico Press, 1974), 49; Ralph E. Twitchell, *The History of the Military Occupation of the Territory of New Mexico from 1848 to 1851* (Denver: Smith–Brooks Company, 1909; reprint, Chicago: Rio Grande Press, 1963), 358–360.

8. For more information about Bond's tenure as Indian agent among the Utes, see Ernest Ingersoll, *Knocking around the Rockies* (New York: Harper and Brothers, 1882), 89; William Henry Jackson, *Time Exposure: The Autobiography of William Henry Jackson* (Albuquerque: University of New Mexico Press, 1986), 224–225; Sidney Jocknick, *Early Days on the Western Slope of Colorado* (Denver: Carson–Harper Company, 1913; reprint, Glorieta, NM: Rio Grande Press, 1968), 81, 103, 106–109; and David P. Smith, *Ouray: Chief of the Utes* (Ridgway, CO: Wayfinder Press, 1990), 131–137. The Jocknick reference includes a photograph of Bond opposite page 107.

9. The Claflin catalogue numbers for these two chief blankets are 24795 and 24796. Amsden, in *Navaho Weaving,* illustrated one of them in plate 98a.

10. W. W. Hill discussed the trade of Navajo blankets to the Utes in "Navaho Trading and Trading Ritual," *Southwestern Journal of Anthropology* 4 (1948): 371–396. Jackson's observation about Navajo blankets in Chief Ouray's home and his reference to buying blankets are from

his *Time Exposure,* 225, 227. Ingersoll's information comes from his *Knocking around the Rockies,* 101. The Museum of Northern Arizona has two blankets in its collection that are attributed to Chief Ouray (catalogue numbers E9061 and E9066).

11. A brief biography of Hatch is included in Charles Wells Chapin's *History of the "Old High School" on School Street, Springfield, Massachusetts, from 1828 to 1840* (Springfield, MA: Press of the Springfield Printing and Binding Company, 1890).

12. I am indebted to Castle McLaughlin, associate curator of North American ethnology at the Peabody Museum, for this information about Morris. It was she who discovered the listing for an attorney by the name of W. R. Morris in the Omaha city directory. She has also conducted research about the trading activities of Herbert Coffeen.

13. Martin F. Schmitt, ed., *General George Crook: His Autobiography* (Norman: University of Oklahoma Press, 1946).

14. John G. Bourke, who fought with General Crook in the Apache wars, noted that in 1870 the quarters at Fort Grant in southern Arizona were decorated with colorful Navajo blankets. Military personnel in the Southwest must have had ready access to such items. See John G. Bourke, *On the Border with Crook* (New York: Charles Scribner's Sons, 1891), 40.

15. Most of my biographical information about Hartwell comes from genealogy sites on the Internet (for example, http://ftp.rootsweb.com/pub/roots-l/messages/97feb/29493). I have been unable to verify this information independently.

16. My information about Hartwell's involvement with the Navajo uprising at Fort Defiance is taken from Frank McNitt's *The Indian Traders* (Norman: University of Oklahoma Press, 1962), 160, and Lawrence R. Murphy's *Frontier Crusader: William F. M. Arny* (Tucson: University of Arizona Press, 1972), 370. It seems quite likely that Agent Arny and Captain Hartwell—both Claflin collectors—knew each other through their assignments at Fort Defiance and Fort Wingate. It is extremely unlikely, however, that they were friends, because relations between Agent Arny and the military personnel at Fort Wingate were strained at best.

17. I obtained this information about Hartwell's death from the Internet site http://ftp.rootsweb.com/pub/roots-l/messages/97feb/29493.

18. The relationship between the Hosmer family and Henry David Thoreau is described by Annie R. Marble in *Thoreau: His Home, Friends and Books* (New York: AMS Press, 1969; first published 1902), 20, 119, 129, 241, and by Milton Meltzer and Walter Harding in *A Thoreau Profile* (Concord, MA: Thoreau Foundation, 1962), 99. Eliza Hosmer's role as an informant on Thoreau is explored by George Hendrick, Willene Hendrick, and Fritz Oehlschlaeger, eds., in *Life of Henry David Thoreau* (Urbana: University of Illinois Press, 1993), xix–xx. Published correspondence between Samuel A. Jones and Alfred Winslow Hosmer makes frequent refer-

ence to Eliza Hosmer (Fritz Oehlschlaeger and George Hendrick, eds., *Toward the Making of Thoreau's Modern Reputation* [Urbana: University of Chicago Press, 1979]).

19. Susan Haskell, collections associate at the Peabody Museum, has collaborated with me on this research and tracked down much of the historical information presented here. We hope to produce a more detailed biography of Eliza Hosmer once we learn more about her collecting activities and her time in the West.

20. My information about the early history of the Ramona School comes from Frances P. Prucha, *The Churches and the Indian Schools, 1888–1912* (Lincoln: University of Nebraska Press, 1979), James E. Roy, "The Ramona Indian School," *American Missionary* 43, no. 8 (New York: American Missionary Association, 1889): 226–228, and "The Ramona School," *American Missionary* 44, no. 3 (New York: American Missionary Association, 1890): 84–85. A list of teachers is provided in vol. 44, no. 2, of *American Missionary* (1890), but Eliza Hosmer's name is not among them. Additional information about the early history of the Ramona School is housed in the archives of the Center for Southwest Research at the University of New Mexico, Albuquerque, in the University of New Mexico (Santa Fe, NM) Collection, 1878–1888. The Ramona School's exhibit in the Woman's Department of the World Columbian Exposition is described in chapter 11 of Hubert Howe Bancroft's *The Book of the Fair* (Chicago: Bancroft Company, 1893).

21. The reference to a Miss Hosmer as assistant matron of the Ramona School comes from an 1894 report by Darwin R. James (*Twenty-sixth Annual Report of the Board of Indian Commissioners for 1894* [Washington, DC: Government Printing Office, 1895], 23–24). The annual reports of the commissioner of Indian affairs for 1893, 1894, and 1895 list a Caroline E. Hosmer as a teacher at the Zia Day School for Zia Pueblo, but we believe her to have been a different person from the Miss Hosmer mentioned in relation to the Ramona School in 1894. At this point it is not known whether this Caroline E. Hosmer was any relation to Eliza Hosmer. The annual reports of the commissioner of Indian affairs list the names of teachers and other employees of the Indian service. I checked these reports for the years 1887 through 1895 and was unable to find Eliza Hosmer's name. It should be noted that these lists include only U.S. government workers, and not employees of the mission and contract schools, such as the Ramona School.

22. Information about Eliza Hosmer's acquisition of Thoreau's herbarium is from Ruth R. Wheeler, "A Thoreau Herbarium," *Thoreau Society Bulletin* 29 (Concord, October 1949); see also the Thoreau Institute's website, http://www.walden.org. Sometime after Eliza Hosmer's death, Thoreau's botanical collection was given to the Thoreau Museum of Natural History of Middlesex School by her nephew George S. Hosmer, of Detroit, Michigan. The collection was

later purchased by the Thoreau Institute at Walden Woods, where it now resides. Information about Eliza Hosmer's botanical connection with Davenport comes from the George Davenport collection at the Gray Herbarium of Harvard University. This collection contains twenty-one letters and seven postcards written by Eliza Hosmer between 1875 and 1877 from various parts of the country; the correspondence is primarily botanical in content. Hosmer's name appears in *The Naturalists' Directory for 1878,* edited by Samuel E. Cassino (Salem, MA: Naturalists' Agency, 1878), 59; *The Naturalists' Directory for 1879,* edited by Samuel E. Cassino (Boston: S. E. Cassino, 1879), 95; *The Naturalists' Directory for 1880,* edited by Samuel E. Cassino (Boston: S. E. Cassino, 1880), 43; and *The Naturalists' Directory for 1884,* edited by Samuel E. Cassino (Boston: S. E. Cassino, 1894), 65.

23. We have gleaned information about Eliza Hosmer's travels from letters in the Davenport correspondence and other sources. The reference to her malaria and the quotation about "the malarial atmosphere" of old Concord come from letters written by Samuel A. Jones to Alfred Hosmer, dated 1902 and 1903 ("Alfred Hosmer's Country Journal, 1888–1903," transcribed with notes by Sarah Chapin, manuscript on file in the Special Collections of the Concord Free Public Library, 5, 9).

24. Claflin gave away at least two of Eliza Hosmer's blankets as gifts during his lifetime. Several others were stolen from his museum in 1978. Most of the latter were later recovered and are now at the Peabody Museum, but two are still missing. One of the missing blankets is the Late Classic blanket (Claflin number 34587) illustrated in Kahlenberg and Berlant, *The Navajo Blanket,* 65. The other missing blanket is described in Claflin's catalogue as a Transitional pictorial decorated with cows and birds (Claflin number 34583).

25. For an excellent biography of Arny's life, see Murphy, *Frontier Crusader.* Arny's career is portrayed in a somewhat less favorable light by Frank McNitt in *Indian Traders.*

26. Murphy, *Frontier Crusader,* 175, 296, 311, 356, 379.

27. The quote from Arny is from his report to the commissioner of Indian affairs, September 15, 1875, published in *Annual Report of the Commissioner of Indian Affairs to the Secretary of the Interior for the Year 1874* (Washington, DC: Government Printing Office, 1874), 308. His commentary on providing Navajos with looms and spinning wheels is from his report of October 19, 1875 (*Annual Report of the Commissioner of Indian Affairs to the Secretary of the Interior for the Year 1875* [Washington, DC: Government Printing Office, 1875], 330); see also Murphy, *Frontier Crusader,* 359. Irvine's statement is from his report of October 1, 1876 (*Annual Report of the Commissioner of Indian Affairs to the Secretary of the Interior for the Year 1876* [Washington, DC: Government Printing Office, 1876], 109).

28. Carolyn O'Bagy Davis, *Treasured Earth: Hattie Cosgrove's Mimbres Archaeology in the*

American Southwest (Tucson: Sanpete Publications and Old Pueblo Archaeology Center, 1995), 6–8.

29. Davis incorrectly states in *Treasured Earth* (81–82, illustration p. 82) that the blanket shown in plate 19 of the present volume is owned by the Laboratory of Anthroplogy (now part of the Museum of Indian Arts and Culture), Museum of New Mexico. In fact, the Laboratory of Anthropology owns a different Cosgrove weaving, a fringed saddle blanket (MNM 9130/12) that it purchased from Burt Cosgrove at the same time it acquired the Late Classic serape given by Arny to Kitty's mother, Amanda Cosgrove (see Amsden, *Navaho Weaving,* pls. 87a, 99). Amsden attributed the Arny blanket shown in plate 87b to the U.S. National Museum.

30. Much of my information about Rowland Gibson Hazard II and his collection is taken from the catalogue by Sarah Peabody Turnbaugh and William A. Turnbaugh, *The Nineteenth-Century Collector: A Rhode Island Perspective* (Peace Dale, RI: Museum of Primitive Art and Culture, 1991).

31. Sarah Peabody Turnbaugh, curator of the Museum of Primitive Art and Culture, personal communication, 2002. The museum has nearly a dozen Southwestern textiles, most, if not all, of which are believed to have been collected by Rowland Gibson Hazard II.

32. My survey of the Southwestern textiles at the Peabody Museum, conducted in the fall of 2000, provides the basis for this catalogue. That survey included only flat, loom-woven blankets, rugs, and mantas and excluded belts, sashes, and leggings. Thus, the totals given here include only the blankets, rugs, and mantas in the Claflin collection, and not these smaller textiles.

33. The two most recent and comprehensive overviews of prehistoric weaving in the American Southwest are Kate Peck Kent's *Prehistoric Textiles of the Southwest* (Albuquerque: University of New Mexico Press, 1983) and Lynn Teague's *Textiles in Southwestern Prehistory* (Albuquerque: University of New Mexico Press, 1998). Both provide extensive information about the use of fibers, looms, and textiles in the Southwest prior to European contact.

34. I discuss the evidence relating to the gender of Pueblo weavers before and after European contact in my dissertation, "The Effects of European Contact on Textile Production and Exchange in the North American Southwest: A Pueblo Case Study" (Department of Anthropology, University of Arizona, Tucson, 1997). See, in particular, pages 94–95, 253–266, and 617–620. I summarize some of this information in my article "The Economics of Pueblo Textile Production and Exchange," in *Beyond Cloth and Cordage: Current Approaches to Archaeological Textile Research in the Americas,* edited by Penelope Ballard Drooker and Laurie D. Webster (Salt Lake City: University of Utah Press, 2000), 179–204.

35. Kiva murals with depictions of ritual clothing have been discovered at the ancestral Pueblo sites of Kuaua (now Coronado State Monument), Pottery Mound, Awatovi, and Kawaika-a. Images of these murals are published in, respectively, Bertha Dutton's *Sun Father's Way* (Albuquerque: University of New Mexico Press, 1963), Frank Hibben's *Kiva Art of the Anasazi at Pottery Mound* (Las Vegas, NV: KC Publications, 1975), and Watson Smith's *Kiva Mural Decorations at Awatovi and Kawaika-a* (Cambridge: Papers of the Peabody Museum of American Archaeology and Ethnology, vol. 36, 1949).

36. For more information about postcontact changes in Pueblo weaving, see my articles "Economics of Pueblo Textile Production" and "An Unbroken Thread: The Persistence of Pueblo Textile Traditions in the Postcolonial Era," in *The Road to Aztlan: Art from a Mythic Homeland,* by Virginia M. Fields, Victor Zamudio-Taylor, et al. (Los Angeles: Los Angeles County Museum of Art, 2001), 174–289.

37. Kate Peck Kent illustrated this stitch in figure 24 of her *Pueblo Indian Textiles: A Living Tradition* (Santa Fe, NM: School of American Research Press, 1983).

38. For more information about Hopi dyes, see Mary-Russell Ferrell Colton's *Hopi Dyes* (Flagstaff: Museum of Northern Arizona Press, 1965) and also Kent, *Pueblo Indian Textiles,* 31 and 63.

39. Kent, *Pueblo Indian Textiles,* 61.

40. Kent provides additional information about this manta style in *Pueblo Indian Textiles,* 65–66.

41. For other distinctive features of Zuni blankets, see Kate Peck Kent, "Spanish, Navajo, or Pueblo? A Guide to the Identification of Nineteenth-Century Southwestern Textiles," in *Hispanic Arts and Ethnohistory in the Southwest,* edited by Marta Weigle with Claudia Larcombe and Samuel Larcombe (Santa Fe, NM: Spanish Colonial Arts Society, 1983), 135–167.

42. An early Spanish document known as the Rabal manuscript describes the weaving and trade of blankets by the Navajos by the early 1700s (W. W. Hill, "Some Navaho Culture Changes during Two Centuries [with a Translation of the Early Eighteenth-Century Rabal Manuscript]," in *Essays in Historical Anthropology of North America,* Smithsonian Miscellaneous Collections no. 100 [Washington, DC: Smithsonian Institution]).

43. W. W. Hill discussed this Navajo blanket trade in "Navaho Trading and Trading Ritual" (see especially his endnotes for chapter 2). For more about the Spanish trade with the Plains tribes, see John C. Ewers, *Indian Life on the Upper Missouri* (Norman: University of Oklahoma Press, 1968), 25.

44. These developmental phases are the same ones Kate Peck Kent used in her *Navajo Weaving: Three Centuries of Change* (Santa Fe, NM: School of American Research Press, 1985),

except that, following the work of Joe Ben Wheat and others, I use the term Late Classic to describe what Kent calls the early Transition period. For slightly different dates and interpretations of Navajo weaving history, see Ann Lane Hedlund, *Navajo Weavings from the Andy Williams Collection* (St. Louis, MO: Saint Louis Art Museum, 1997); Marian Rodee, *Weaving of the Southwest* (West Chester, PA: Schiffer Publishing, 1987); and Kathleen Whitaker, *Common Threads: Pueblo and Navajo Textiles in the Southwest Museum* (Los Angeles: Southwest Museum, 1998) and *Southwest Textiles: Weavings of the Navajo and Pueblo* (Seattle: University of Washington Press, 2002).

45. In a recent dye analysis of a group of textiles at the School of American Research in Santa Fe, Casey Reed, using high-pressure liquid chromatography, identified cochineal dye in a handspun yarn from a Moqui-style blanket (T. 109). Marian Rodee, who worked with Reed on the project, believes that additional dye testing will show greater usage of this expensive but easy-to-use dye by Navajo and Pueblo weavers (personal communication, 2003).

46. Joe Ben Wheat dated the shift from three-ply to four-ply yarns in Southwestern textiles to the period 1873–1875, whereas Kathleen Whitaker suggests that the change had occurred by 1870. See Wheat's essay "Yarns to the Navajo: The Materials of Weaving," in *A Burst of Brilliance: Germantown and Navajo Weaving,* by Joe Ben Wheat and Lucy Fowler Williams (Philadelphia: University of Pennsylvania Press, 1994), 14, and Whitaker, *Southwest Textiles,* 33. Ann Lane Hedlund also cites Wheat's dates in *Beyond the Loom: Keys to Understanding Early Southwestern Weaving* (Boulder, CO: Johnson Publishing, 1990), 23, 96. My dates for the Claflin textiles are based on Wheat's dates for this change.

47. I am indebted to Marian Rodee for pointing out the importance of these forts as weaving centers.

48. Both one-piece and two-piece Navajo dresses were found at the 1805 site of Massacre Cave, located in what is now Canyon de Chelly National Park. Kent (*Navajo Weaving,* 61) reached a similar conclusion about the so-called fancy mantas. Hedlund discusses this idea about the origins of the two-piece dress in *Navajo Weavings from the Andy Williams Collection,* 17.

49. The dates and phase names used here generally follow those used by Kent in *Navajo Weaving,* 53. W. W. Hill discussed the importance of the chief blanket in Navajo-Ute trade relations ("Navajo Trading and Trading Ritual," 380).

50. These two blankets (Claflin catalogue numbers 24795 and 24796) were collected from Southern Utes by Indian agent Henry F. Bond. Amsden illustrated one of them in plate 98a of *Navaho Weaving.*

51. Amsden, *Navaho Weaving,* plate 106a.

52. Joe Ben Wheat discussed the so-called fancy manta style in his article "Navajo Textiles,"

in *The Fred Harvey Fine Arts Collection,* edited by Byron Harvey (Phoenix: Heard Museum, 1976), 11; see also Kent, *Navajo Weaving,* 61.

53. This information comes from Joe Ben Wheat's 1973 analysis of this textile. Copies of his analysis forms for the Claflin collection are on file at the Peabody Museum.

54. The Museum of Indian Art and Culture (MIAC) in Santa Fe has a serape in its collection with a color palette, design, and layout virtually identical to those of the serape shown in plate 12 (PM 995−2−10/74614). Unlike the Peabody example, the MIAC piece (36269/12) has a decorative fringe of multicolored, (probably) commercial yarns applied to both ends. MIAC gives a date for its serape as circa 1890−1915. I have not had a chance to examine this piece, but I suspect the date is based on the presence of the applied fringe. Such fringes were very popular during the late nineteenth century and were sometimes added to older weavings.

55. Hosmer collected three other Late Classic serapes that were acquired by Claflin but are not part of the Claflin collection at the Peabody Museum. Two of these (Claflin catalogue numbers 34585 and 34586) were given away by Claflin as gifts, and a third (34587) was stolen during the burglary at his museum in 1978. The last is illustrated as number 40 on page 65 of Kahlenberg and Berlant, *The Navajo Blanket,* and also as figure 48 in Berlant and Kahlenberg, *Walk in Beauty.*

56. Ann Lane Hedlund presents Wheat's research on selvage composition in *Beyond the Loom,* 22, 87, and in Wheat's *Blanket Weaving in the Southwest.* Kate Peck Kent discussed the different technical features of Southwestern textiles in her 1983 article, "Spanish, Navajo, or Pueblo?"

57. I examine three of these revival movements, including the Hubbell and Chinle revival movements, in my article "Reproducing the Past: Revival and Revision in Navajo Weaving," *Journal of the Southwest* 38, no. 4 (1996): 415−432.

58. Hubbell advertised a selection of textiles in *Navajo Blankets and Indian Curios, Catalogue and Price List, J. L. Hubbell, Indian Trader, Ganado, Apache County, Arizona* (Chicago: Press of Hollister Brothers, 1905). Frank McNitt offered an in-depth look at the trading activities of Juan Lorenzo Hubbell and the Chinle-area traders in his excellent book *The Indian Traders,* and Martha Blue discusses Hubbell's trading activities in her recent biography *Indian Trader: The Life and Times of J. L. Hubbell* (Walnut, CA: Kiva Publishing, 2000). A more controversial interpretation of Hubbell's trading practices is presented by Kathy M'Closkey in *Swept under the Rug: A Hidden History of Navajo Weaving* (Albuquerque: University of New Mexico Press, 2002).

59. I am grateful to Kathleen Whitaker for pointing out that Claflin's Mike Quirk was probably trader Mike Kirk. In *Indian Traders,* 215, 337, McNitt states that a Mike Kirk worked for

Hubbell at his Chinle trading post in the early 1900s and was a trader in Gallup by the 1920s. Based on the fact that Claflin was unsure about the spelling of this person's name (he wrote "Quirk?" with a question mark), and given Mike Kirk's known association with Hubbell, there is little doubt that Mike Kirk is the person to whom Claflin referred.

60. Amsden, *Navaho Weaving,* 143, n. 11. Amsden gave a later date of manufacture for this blanket than did Claflin, writing that it was made "not long before the year 1910."

61. Amsden, *Navaho Weaving,* plate 121 (inside back cover). Kathleen Whitaker (*Common Threads,* 65, left, and *Southwest Textiles,* 322) illustrates another revival weaving with red yarns. For further discussion of these DuPont dyes, see Amsden, *Navaho Weaving,* 228–229, and Whitaker, *Southwest Textiles,* 322.

62. Susan Lowell, *Ganado Red* (Minneapolis: Milkweed Editions, 1988).

GLOSSARY OF
SOUTHWESTERN WEAVING TERMS

For other Southwestern weaving glossaries, see Ann Lane Hedlund, *Beyond the Loom* (1990), Kate Peck Kent, *Prehistoric Textiles* (1983), and Kathleen Whitaker, *Common Threads* (1998) and *Southwest Textiles* (2002).

DIYUGI. A Navajo word meaning "soft, fluffy blanket." The term is used by Southwestern textile historians to describe handspun Navajo blankets with simple designs made during the late nineteenth and early twentieth centuries. Also spelled *diyogi*.

DYE. A colorant permanently fixed to fibers.

COCHINEAL. A natural red dye derived from the dried body of the female insect *Dactylopius coccus,* which lives on the nopal cactus. Native to Central and South America, Mexico, and the Sonoran Desert of the southwestern United States. The primary colorant is carminic acid.

INDIGO. A natural blue dye obtained from plants of the genus *Indigofera,* native to various tropical regions of the world. The indigo dye used by Hispanic, Navajo, and Pueblo weavers was imported from Mexico in the form of semiprocessed cakes.

LAC. A natural red dye extracted from the resinous secretions of the scale insect *Laccifer (Tachardia) lacca,* native to Southeast Asia. The primary colorant is laccaic acid.

NATIVE DYE. A natural dye made from any number of locally available plants or minerals. Navajo and Pueblo weavers made a native black dye by combining sumac or sunflower seeds with yellow ochre and piñon pitch.

SYNTHETIC DYE. A commercial dye synthesized from chemicals. The earliest synthetic dyes are called aniline dyes and were developed in the 1850s.

VEGETAL DYE. A natural dye derived from the twigs, leaves, flowers, roots, or bark of plants.

EMBROIDERY. A technique used to add decorative yarns to a completed ground fabric by means of a needle.

LAZY LINE. A diagonal break in the weave of a fabric, similar to the structure of a diagonal tapestry join but appearing in solid-colored sections of a fabric. Lazy lines are a labor-saving technique that allows a weaver to build up wedge-shaped sections of a fabric and avoid having to weave the entire width of a fabric all at once.

LOOM. A weaving device that maintains warp yarns under tension and parallel to each other. A true loom is equipped with one or more heddles for manipulating different sets of warps. Historically, four types of looms have been used in the Southwest:

BACKSTRAP LOOM. A loom consisting of two rods wound with a continuous warp, a shed rod, and (usually) string-loop heddles, in which one rod is attached to the weaver by means of a strap, and the other is attached to a fixed object. In North America, this loom is indigenous to Mexico and the southwestern United States.

HORIZONTAL LOOM. A loom consisting of two rods wound with a continuous warp, a shed rod, and (usually) string-loop heddles, in which the rods and warp elements are arranged parallel to the ground. In North America, this loom is indigenous to the O'odham (Pimas, Papagos) of southern Arizona, probably to the prehistoric Hohokam culture, and to several groups in northwest Mexico, including the Tarahumaras and Mayos.

TREADLE LOOM. A mechanized, wood-frame loom equipped with reed heddles and foot pedals (treadles), used to weave long lengths of cloth. This loom was introduced to the Western Hemisphere in the sixteenth century, during the early years of Spanish colonization. In the American Southwest, it was and is used primarily by Hispanic weavers in the Rio Grande Valley.

UPRIGHT OR VERTICAL LOOM. A loom consisting of two rods wound with a continuous warp, a shed rod, and string-loop heddles, in which the rods and warp are arranged perpendicular to the ground. In North America, this loom is indigenous to the ancestral Pueblo Indians, the historic Pueblos, and the historic Navajos.

MANTA. A Spanish word for blanket, used to describe a rectangular fabric that is woven wider in the weft direction than in the warp direction (that is, wider than long). Worn by Navajo and Pueblo people, usually women, as a shawl or wraparound dress.

SALTILLO. A nineteenth-century style of Mexican serape named after a city in northern Mexico, typically decorated with any combination of center-dominant diamonds, vertical zigzags, and small serrated motifs. During the mid-nineteenth century, these designs and layouts were imitated by New Mexican Hispanic weavers and, by the 1860s, by Navajo and some Pueblo weavers.

SERAPE. A Spanish word used to describe a rectangular fabric woven longer in the warp direction than in the weft direction (that is, longer than wide). Hispanic, Navajo, and Pueblo people used serapes, many of them highly decorated, as shoulder blankets and ponchos and as sleeping blankets.

SELVAGE. The uncut, finished edge of a fabric, where the weft or warp elements make a turn around the outside elements and reenter the web. Navajo and Pueblo textiles made on the upright loom typically have four complete selvages and often two or more yarns called **selvage cords** twined along the warp and weft edges. Hispanic and other textiles woven on a treadle loom typically have two complete weft (side) selvages and two cut warp (end) selvages, the latter usually tied off as fringe.

WARP. The parallel yarns that are fixed to a loom during the weaving process and that provide a foundation for the transverse weft elements.

WEFT. The yarns that are interworked with the fixed warp elements.

WEAVE. The process of interlacing yarns to make a fabric, or the structure of an interlaced fabric.

FINGER WEAVES. Weaves produced without a loom apparatus with heddles. **Looping** is a single-element construction in which a single yarn is drawn through a succession of loops to form a fabric. In **braiding**, also known as oblique interlacing, a single set of parallel elements passes over and under adjacent elements in a diagonal or oblique fashion. **Twining** is a nonloom, warp-weft weave in which two or more elements from an active set make a half-turn around each other after enclosing an element of the passive set. In **weft twining**, weft strands make a half-turn around each other after enclosing a warp; in **warp twining**, warp strands make a half-turn around each other between each passage of weft.

OPENWORK WEAVES. Weaves that produce holes or slits in fabrics. In **gauze weave**, adjacent pairs of warps are crossed and uncrossed prior to the insertion of the weft. In **weft-wrap openwork**, selected groups of warps are wrapped with weft yarns at intervals to produce openwork designs. Both techniques were used in the Southwest prior to European contact.

PLAIN WEAVE. A weave in which a single weft yarn passes over and under a single warp yarn. In **balanced plain weave**, the warp and weft yarns are visible and evenly balanced. In **weft-faced plain weave**, the weft elements obscure the warps. In **warp-faced plain weave**, the warp elements obscure the wefts.

SUPPLEMENTARY WEFT. A technique used to add decorative yarns to a ground fabric during the weaving process, in which supplementary (extra) wefts float over and under selected groups of warp yarns to create a design. Also called **brocade**, this was a popular decorative technique among Southwestern weavers in the centuries just prior to European contact. Sometime after Spanish contact, Hopi weavers devised a new method of adding supplementary wefts during the weaving process, known as **Hopi brocade**. Technically not a true brocade, Hopi brocade is a **supplementary weft-wrap** technique in which the colored wefts float over eight warps, then wrap completely around the last two warps before floating over the next group of eight.

TAPESTRY WEAVE. A weft-faced plain weave made with discontinuous wefts, in which different colors of weft yarns are worked back and forth in sections to produce colored patterns. This weave structure has been used by Navajo, Hispanic, and some Pueblo weavers to produce geometric designs and by Navajos to make pictorial designs. **Twill tapestry**, a variation of tapestry weave, is a diagonal float weave made with discontinuous wefts.

TWILL WEAVE. A float weave in which the weft passes over two or more warps and the floats are diagonally aligned. Southwestern weavers combine different arrangements of floats to create **diagonal**, **diamond**, and **herringbone** (zigzag) **twills**.

YARN. A continuous strand of twisted fibers.

COMMERCIAL. A commercially manufactured, machine-spun yarn.

GERMANTOWN. A commercial, synthetic-dyed, three- or four-ply wool yarn originally manufactured in Germantown, Pennsylvania. The term is also used generically to refer to any synthetic-dyed, machine-spun yarn used by Southwestern weavers, including yarns produced in other mills, and to refer to Transition-period Navajo weavings made primarily of these yarns. Three-ply Germantown yarns were first issued to the Navajos in the early 1860s at Bosque Redondo and were replaced by four-ply yarns sometime in the early to mid-1870s.

HANDSPUN. A yarn spun by hand, as opposed to a machine-spun yarn. In the Southwest, handspun yarns were spun by means of a stick-and-whorl spindle or the European-introduced spinning wheel. Generally, Navajo and Pueblo spinners use the former, Hispanic spinners the latter.

RAVELED. Threads obtained by unraveling a woven piece of cloth. In the Southwest, this was most often done by Navajo weavers to obtain red threads for their weavings, prior to the wide availability of red commercial yarns or packaged synthetic dyes. Such threads were unraveled from woolen trade cloth, commonly known as **bayeta** (Spanish; in English, baize), that was imported into the Southwest from a variety of sources. Red **early raveled cloth** (to 1865) is finely woven and was dyed with cochineal or lac until 1860, when synthetic dyes were used. **Late raveled cloth** (1865–1890) is usually coarser, is colored exclusively with synthetic dyes, and includes a fuzzy variant called **American flannel**. Until the 1880s,

and later in some revival textiles, Navajo (and occasionally Pueblo and Hispanic) weavers used these raveled threads as weft elements in their handwoven fabrics, either by laying them in directly as groups of threads or by carding and spinning them into new yarns. These latter yarns, referred to as **raveled**, **recarded**, and **respun yarns**, include a type known as **carded pink**, popular between 1865 and 1880, that was made by carding and spinning raveled red threads and native white wool fiber together.

SAXONY. A commercial, natural-dyed, three-ply yarn of lustrous merino wool, manufactured in the former German state of Saxony and also in England, France, and New England during the first half of the nineteenth century. Found in Navajo textiles made between 1840 and 1865 and also in some Pueblo and Hispanic weavings.

YARN STRUCTURE (SPIN, PLY, TWIST). **Spinning** is the process of twisting fibers and yarns together to form a thread, yarn, or cord. An individual strand of spun yarn is called a **ply**. **Plying** is the process of twisting two or more strands or plies of yarn together to make a **plied yarn**. A single-ply yarn is a single strand of spun fibers; a two-ply yarn consists of two strands of yarn that have been twisted or plied together; a three-ply yarn consists of three strands plied together; and so on. The letters *S* and *Z* are used to describe the direction of spin or twist. In an **s-spun yarn**, the fibers are aligned in the same direction as the center portion of the letter *S* (\), whereas in a **z-spun yarn**, the fibers are aligned like the center portion of the letter *Z* (/). A lowercase *s* or *z* refers to a single-ply yarn. An uppercase *S* or *Z* refers to the **final twist** (that is, the most visible twist) of a multi-ply yarn. For example, the notation 2z-S describes a yarn composed of two z-spun plies that have been twisted together in the S direction, whereas 3(2z-S)Z describes a yarn composed of three 2z-S plies that have been twisted together in the Z direction.

SUGGESTED READING

Amsden, Charles A.

1934 *Navaho Weaving: Its Technic and History.* Los Angeles: Southwest Museum. Reprint,
 1982, Glorieta, NM: Rio Grande Press.

Bennett, Noel, and Tiana Bighorse

1997 *Navajo Weaving Way: The Path from Fleece to Rug.* Loveland, CO: Interweave Press.

Berlant, Anthony, and Mary Hunt Kahlenberg

1977 *Walk in Beauty: The Navajo and Their Blankets.* Boston: New York Graphic Society.

Blomberg, Nancy J.

1988 *Navajo Textiles: The William Randolph Hearst Collection.* Tucson: University of Arizona
 Press.

Bonar, Eulalie H.

1996 *Woven by the Grandmothers: Nineteenth-Century Navajo Textiles from the National
 Museum of the American Indian.* Washington, DC: Smithsonian Institution Press.

Campbell, Tyrone, Joel Kopp, and Kate Kopp

1995 *Navajo Pictorial Weaving, 1880–1950.* Albuquerque: University of New Mexico Press.

Colton, Mary-Russell Ferrell
1965 *Hopi Dyes.* Flagstaff: Museum of Northern Arizona Press.
Fox, Nancy L.
1978 *Pueblo Weaving and Textile Arts.* Santa Fe: Museum of New Mexico Press.
Getzwiller, Steve
1984 *The Fine Art of Navajo Weaving.* Tucson: Ray Manley Publications.
Hedlund, Ann Lane
1990 *Beyond the Loom: Keys to Understanding Early Southwestern Weaving.* Boulder, CO: Johnson Publishing.
1992 *Reflections of the Weaver's World.* Denver: Denver Art Museum.
1997 *Navajo Weavings from the Andy Williams Collection.* St. Louis, MO: Saint Louis Art Museum.
James, H. L.
1988 *Rugs and Posts: The Story of Navajo Weaving and Indian Trading.* West Chester, PA: Schiffer Publishing. Also published as *Posts and Rugs* in a different edition.
Kahlenberg, Mary Hunt, and Anthony Berlant
1972 *The Navajo Blanket.* Westport, CT: Praeger Publishers, in association with the Los Angeles County Museum of Art, Los Angeles.
Kent, Kate Peck
1983 *Prehistoric Textiles of the Southwest.* Albuquerque: University of New Mexico Press.
1983 *Pueblo Indian Textiles: A Living Tradition.* Santa Fe, NM: School of American Research Press.
1983 "Spanish, Navajo or Pueblo? A Guide to the Identification of Nineteenth-Century Southwestern Textiles." In *Hispanic Arts and Ethnohistory in the Southwest,* edited by Marta Weigle with Claudia Larcombe and Samuel Larcombe, pp. 135–167. Santa Fe, NM: Spanish Colonial Arts Society .
1985 *Navajo Weaving: Three Centuries of Change.* Santa Fe, NM: School of American Research Press.
McManis, Kent, and Robert Jeffries
1997 *A Guide to Navajo Weavings.* Tucson: Treasure Chest Books.
Moore, J. B.
1987 *A Collection of Catalogs Published at Crystal Trading Post, 1903–1911.* Albuquerque: Awanyu Publishing Company.
Pendleton, Mary
1974 *Navajo and Hopi Weaving Techniques.* New York: Collier Books.

Reichard, Gladys

1936 *Navajo Shepherd and Weaver.* New York: J. J. Augustin.

Rodee, Marian

1981 *Old Navajo Rugs: Their Development from 1900 to 1940.* Albuquerque: University of New Mexico Press.

1987 *Weaving of the Southwest.* West Chester, PA: Schiffer Publishing.

1995 *One Hundred Years of Navajo Rugs.* Albuquerque: University of New Mexico Press.

Roediger, Virginia M.

1941 *Ceremonial Costumes of the Pueblo Indians: Their Evolution, Fabrication, and Significance in the Prayer Drama.* Berkeley: University of California Press. Reprint, 1991.

Teague, Lynn S.

1998 *Textiles in Southwestern Prehistory.* Albuquerque: University of New Mexico Press.

Webster, Laurie D.

1996 "Reproducing the Past: Revival and Revision in Navajo Weaving." *Journal of the Southwest* 38(4):415–432.

2000 "The Economics of Pueblo Textile Production and Exchange in Colonial New Mexico." In *Beyond Cloth and Cordage: Current Approaches to Archaeological Textile Research in the Americas,* edited by Penelope Ballard Drooker and Laurie D. Webster, pp. 179–204. Salt Lake City: University of Utah Press.

2001 "An Unbroken Thread: The Persistence of Pueblo Textile Traditions in the Postcolonial Era." In *The Road to Aztlan: Art from a Mythic Homeland,* by Virginia M. Fields, Victor Zamudio-Taylor, et al., pp. 174–289. Los Angeles: Los Angeles County Museum of Art.

Wheat, Joe Ben

1977 "Documentary Basis for Material Changes and Design Styles in Navajo Blanket Weaving." In *Ethnographic Textiles of the Western Hemisphere,* edited by Irene Emery and Patricia L. Fiske, pp. 420–444. Irene Emery Roundtable on Museum Textiles, 1976 Proceedings. Washington, DC: The Textile Museum.

1979 "Rio Grande, Pueblo, and Navajo Weavers: Cross-Cultural Influence." In *Spanish Textile Tradition of New Mexico and Colorado,* compiled and edited by Nora Fisher, pp. 29–36. Santa Fe: Museum of International Folk Art, Museum of New Mexico Press. Reprinted 1994 by the Museum of New Mexico Press as *Rio Grande Textiles,* compiled and edited by Nora Fisher, pp. 22–26.

2003 *Blanket Weaving in the Southwest.* Edited by Ann Lane Hedlund. Tucson: University of Arizona Press.

Wheat, Joe Ben, and Lucy Fowler Williams

1994 *A Burst of Brilliance: Germantown and Navajo Weaving.* Philadelphia: University of Pennsylvania Press.

Whitaker, Kathleen

1998 *Common Threads: Pueblo and Navajo Textiles in the Southwest Museum.* Los Angeles: Southwest Museum.

2002 *Southwest Textiles: Weavings of the Navajo and Pueblo.* Seattle: University of Washington Press, in association with the Southwest Museum, Los Angeles.

Willink, Roseann S., and Paul G. Zolbrod

1996 *Weaving a World: Textiles and the Navajo Way of Seeing.* Santa Fe: Museum of New Mexico Press.

Young, Stella

1978 *Navajo Native Dyes: Their Preparation and Use.* Palmer Lake, CO: Filter Press. Originally published in 1940 by the Bureau of Indian Affairs.